IMAGES
of America

JEWS OF SPRINGFIELD
IN THE OZARKS

SHALOM

Temple Israel is pleased to welcome all Jewish Students. We invite you to join our Sabbath Worship Services Friday evenings 8:00 p.m. We also provide our High Holiday Worship Services. Each service is followed by a Kiddush.

The synagogue in Springfield has always welcomed Jewish students who attend Missouri State University and Drury University. Neither institution has enough students for a Jewish student group. The congregation lets the students know of its existence and their welcome through word of mouth and advertisements in the campus papers. The rabbi, when contacted, forwards the students' contact information to Jewish faculty at the appropriate campuses. (Courtesy of Special Collections and Archives, Missouri State University.)

ON THE COVER: Louis Barth bought out Nathan's on the square and opened Barth's Clothing Co. This store, both as Nathan's and then as Barth's, was the foundation of the city square until the business closed. The building is now owned by the History Museum for Springfield–Greene County and will become its new headquarters. (Courtesy of the History Museum for Springfield–Greene County.)

IMAGES
of America

JEWS OF SPRINGFIELD
IN THE OZARKS

Mara W. Cohen Ioannides
and M. Rachel Gholson, PhD

ARCADIA
PUBLISHING

Copyright © 2013 by Mara W. Cohen Ioannides and M. Rachel Gholson, PhD
ISBN 978-0-7385-9094-3

Published by Arcadia Publishing
Charleston, South Carolina

Printed in the United States of America

Library of Congress Control Number: 2012948000

For all general information, please contact Arcadia Publishing:
Telephone 843-853-2070
Fax 843-853-0044
E-mail sales@arcadiapublishing.com
For customer service and orders:
Toll-Free 1-888-313-2665

Visit us on the Internet at www.arcadiapublishing.com

To the Jews who came to Springfield and the community that
welcomed them. Together they made history—and Springfield.

CONTENTS

Acknowledgments 6

Introduction 7

1. Religion 9

2. Business 35

3. Founders and Leaders of the Jewish Community 65

4. Jewish Leaders in the Springfield Community 79

5. Community Service 87

6. Education 97

7. Social Activities and the Arts 113

ACKNOWLEDGMENTS

We could not have completed this book without the assistance of many people. Joan Hampton-Porter, the curator at the History Museum for Springfield–Greene County, Springfield, Missouri, provided access to its collections and advice on where to find information. In addition, the staff scoured its collection for appropriate photographs and tidbits of information. David Richards and the staff at Special Collections and Archives, Meyer Library, Missouri State University (which houses among its collections the Ozarks Jewish Archives) were equally helpful. Archivist Anne Baker has an uncanny ability to know where everything is, and Shannon Western Mawhiney digitized many items, collecting images from the collections as she did so. Kevin Proffitt and his staff at the Jacob Rader Marcus Center of the American Jewish Archives, Cincinnati, Ohio, were most generous with their time and materials as well. We are pleased that much of what we have collected will be added to the Ozarks Jewish Archives at Special Collections and Archives, Meyer Library, and the Springfield, Missouri, Collection at the Jacob Rader Marcus Center of the American Jewish Archives in Cincinnati, Ohio, to aid others in understanding the lives and roles of Jews in the Ozarks. The staff at Wilson's Creek National Battlefield helped with our Civil War materials, and Stephen M. Cohen supplied assistance in genealogical research and location of decendants of local families, for which we are grateful. We appreciate all the families, both in Springfield and across the country, who willingly and graciously shared their families' histories and photographs, providing a peek into the experiences of Springfield Jewry.

INTRODUCTION

Part of the purpose of this photographic history is to fill the gap in the Jewish historical records of both Springfield, Missouri, and the United States. No book-length history on Springfield's Jewish population exists, and this is a tragedy not only for the local Jewish and non-Jewish communities but also the national historical records.

The Ozarks, the region in which Springfield sits, is unique both geographically and culturally. Located in four states (Arkansas, Kansas, Missouri, and Oklahoma) and across three regions (Midwest, North, and South), the region is physically bordered on three sides by rivers—the Mississippi to the east, the Missouri to the north, the Arkansas to the south, and the Grand River to the southwest—and by geological markers to its west. Culturally, however, the region is defined as expanding east towards the Missouri Bootheel and circling down into Arkansas north of Fort Smith.

The earliest population was Native American. French explorers then claimed the area for France, and only Catholics were allowed to live in the region. Once the area was purchased by Jefferson as part of the Louisiana Purchase in 1803, a large influx of Appalachian Scotch-Irish and Germans began. This group of arrivals had a profound cultural influence.

Jews began arriving during what Jewish American historians call the Second Great Wave of Immigration, which roughly corresponds to the post–Civil War expansion period and the Great German Immigration. (The First Great Wave immigrants were those who came between 1654, when the first Jews landed in North America at New Amsterdam, now New York City, and the 1820s.) The Second Wave Jews were German, having left what we now call Germany for the same reason their Christian counterparts did: economics. These German Jews were Reform, or liberal, and greatly involved in the secular society in which they lived. They were also the first Jews who joined in with the Western Expansion Movement and started Jewish communities across the West.

The Third Great Wave of Jewish immigration occurred between 1880 and 1914 (the beginning of World War I), when large numbers of Eastern European Jews fled the poor economic conditions and rising anti-Semitism of their homelands. Between 1880 and 1910, the estimated Jewish population in the United States grew from 230,237 to 2,044,762. Springfield, Missouri, was incorporated in 1838, seventeen years after Missouri became a state. Between 1880 and 1910, the Jewish population in Missouri grew from an estimated 35,000 to 52,000. In contrast to the earlier Jewish immigrants, many of these people were poor and Orthodox, or traditional. This third group of Jews followed the Germans Jews west and established their own religious communities because they did not like the American style of worship or the compromises of Judaism to American idealism—as they interpreted the Reform Movement.

Over time, however, most small American towns could not sustain two Jewish communities; there simply were not enough Jews. Additionally, Orthodoxy, with its strict adherence to rabbinic regulation, did not translate well with the distances between Jews in the American West. So Orthodox communities shrank until their only options were to close or merge, and most chose

merger with the Reform congregations.

Springfield's Jewish community is no different in this respect from others in the West. First to arrive were the Reform Jews starting in the 1860s. In 1893, there were enough Reform Jews to incorporate a congregation and buy a cemetery. In 1918, the Orthodox community was finally large enough to incorporate. By the 1930s, there were not enough Jews to support two congregations, and in the 1940s, the congregations merged. It was a slow process. First, the Orthodox congregation shared the Reform congregation's building. Then, they shared the support of a rabbi. Finally, they joined the Reform congregation completely, giving up their separate prayer books and services. Today, the congregation is aligned with the Reform Movement (Union of American Hebrew Congregations), but not all members define themselves as Reform Jews. There are those who are Orthodox, and those who are secular, but all Jews are welcome. In fact, there are still vestiges of Orthodox practices during religious services as a compromise with the Orthodox members.

The Jews of Springfield are very much like the Jews of small communities across the Midwest and the South. The first to arrive were merchants, who opened stores and provided opportunities for families by bringing their siblings and cousins to the United States and these small communities. Most of the first families in Springfield were related when they arrived or subsequently married with each other, making the community a large family in more than just the sharing of their religion. The second generation became more educated, and the third even more so. As with many small Jewish communities, these second and third generations moved away to seek opportunities more aligned with their interests. Their parents did not expect them to stay and work in the family businesses.

What makes Springfield different is that this community did not die. Many small Jewish communities (those with under 200 member families) closed in the 1970s and thereafter because they could not sustain a synagogue with their limited memberships. The community in Springfield hovers around 120 member families (fluctuating some from year to year) because Springfield is the medical hub for the Ozarks, with two major hospital complexes (Mercy Hospitals and Cox Hospitals) and two of the oldest universities in the state (Missouri State University and Drury University) within the city limits. These keep the Jewish community thriving. However, unlike larger long-term communities in major metropolises, there is little continuity of families; membership does not span multiple generations.

This account is by no means complete, which was not purposeful on our part. Many of those families who have left the area are difficult to locate, a few chose not to participate, and the process of gathering materials is time-consuming. We were extraordinarily lucky to be able to include many long-forgotten families, and we have done our best to present an accurate, rounded, and complete history of this community. Additionally, we hope putting faces to names listed on synagogue records will help these people be reincorporated into community memory.

One

RELIGION

Rabbi David Zucker was the religious leader of United Hebrew Congregations from 1984 until 1985. He also taught courses about the Hebrew Bible at both Missouri State University and Drury University. Here, he reads from the Torah—the holy scrolls, containing the Biblical books of Genesis, Exodus, Leviticus, Numbers, and Deuteronomy. The Torah is made from animal skin and is hand copied from another Torah by a scribe. Rabbi Zucker uses a *yad* (Hebrew for "hand") to follow along, as demanded by Jewish law, so that he does not dirty the handwritten manuscript with the oil on his skin. The Torah is read on the Sabbath, and the portion is proscribed in an annual cycle that is almost two thousand years old. (Courtesy of the *Springfield News-Leader.*)

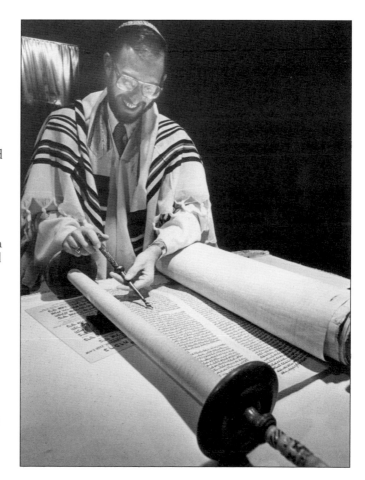

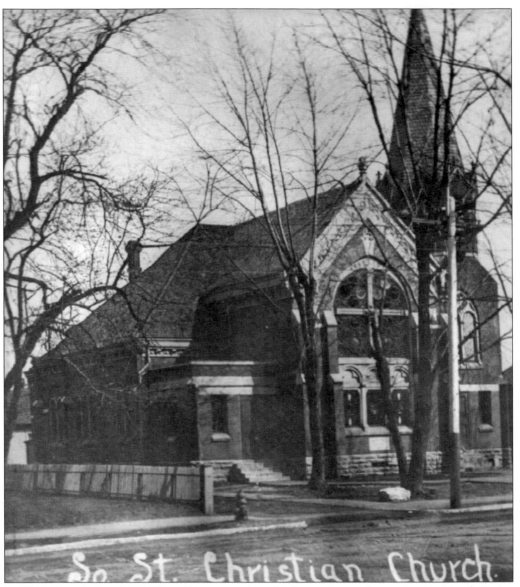

In 1894, Temple Israel held Yom Kippur services, both evening and morning, in South Street Christian Church. These are the first known Jewish services to be held in Springfield, although they most certainly had other services for the Sabbath and holidays in people's homes. (Courtesy of South Street Christian Church.)

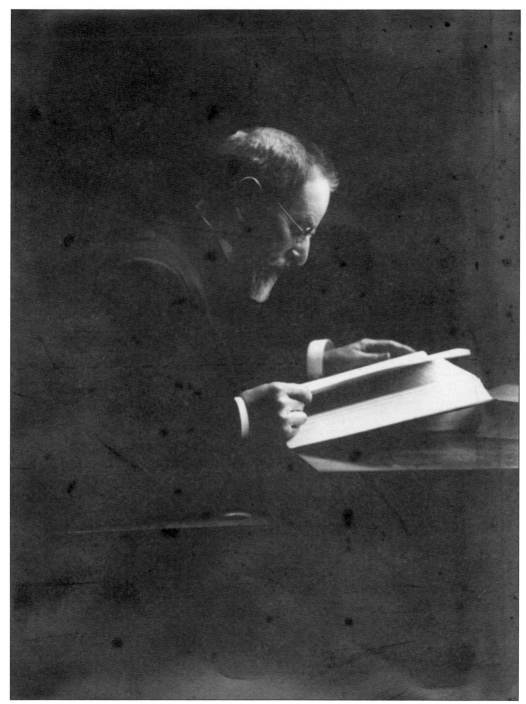

Dr. Messing was identified in the *Springfield Weekly Republican* as the rabbi who delivered the sermons at the 1894 Yom Kippur services. Rabbi Henry J. Messing was the rabbi at United Hebrew Congregation, St. Louis, Missouri, from 1878 to 1911 and was, presumably, the rabbi who came to Springfield to lead these services. (Courtesy of St. Louis Jewish Community Archives, JCCA Collection.)

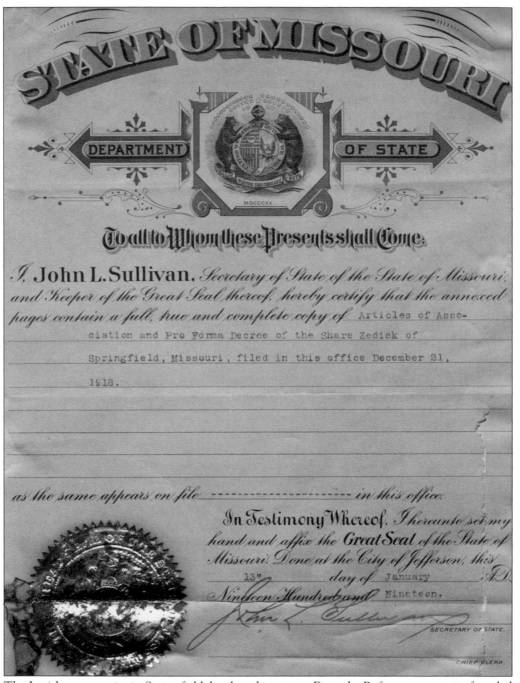

The Jewish community in Springfield developed in stages. First, the Reform community founded Temple Israel in 1893; these were German Jews. In 1918, the Eastern European Orthodox community founded Sha'are Zedek (Gates of Wisdom). After World War II, the Orthodox group moved into the building constructed by the Reform congregation. In 1972, the two groups merged, becoming United Hebrew Congregations. (Courtesy of Temple Israel.)

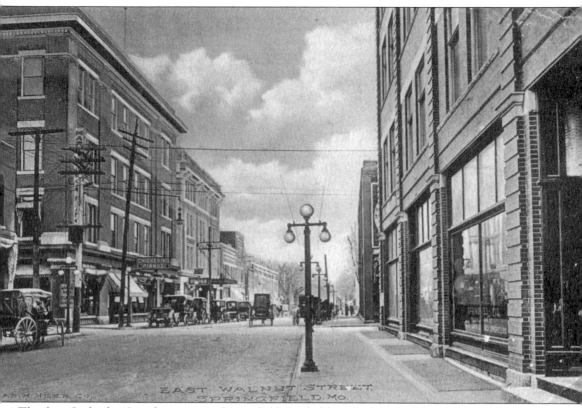

The first Orthodox Jewish service in Springfield was held in the home of Benjamin Karchmer in 1912. Then, in 1918, the group wrote its charter, rented a room in the Masonic temple on Walnut Street, and named itself Sha'arc Zedek. The room is seen just behind the tall electric pole, above the piano sign, in this c. 1911 postcard. (Courtesy of the History Museum for Springfield–Greene County.)

On November 30, 1930, the first synagogue was dedicated. Built and funded by the Reform congregation, the edifice cost the community $16,000 and still stands at the corner of Kickapoo Avenue and Belmont Street. Three religious leaders came to the ceremony: Rabbi Iola of Tulsa dedicated the building, and two Christian ministers spoke at the occasion. After World War II, the Orthodox community paid off the mortgage and started using the location as well. The building was sold in 1996. (Courtesy of the History Museum for Springfield–Greene County.)

Rabbi Hyman A. Iola, from Temple Israel in Tulsa, Oklahoma, was the nearest rabbi and helped dedicate the first synagogue in Springfield in 1930. Iola, who had graduated from Hebrew Union College in Cincinnati, Ohio, in 1921, served the Tulsa community for five years (1930–1935) before moving to Tucson, Arizona. (Courtesy of Temple Israel, Tulsa, Oklahoma.)

Temple Israel proudly celebrated its 50th anniversary in 1943. Nathan Karchmer and Arthur Rubenstein, whose families helped found the Orthodox congregation, were very involved in the ceremony, as were the newer members who were leaders in the Jewish and larger community: Lester Strauss, Moe Fayman, Burton Frieberg, Louis Barth, Edgar Herman, David LeBolt, Irving Schwab, E.N. Pollack, and Edward Lurie. (Courtesy of Special Collections and Archives, Missouri State University.)

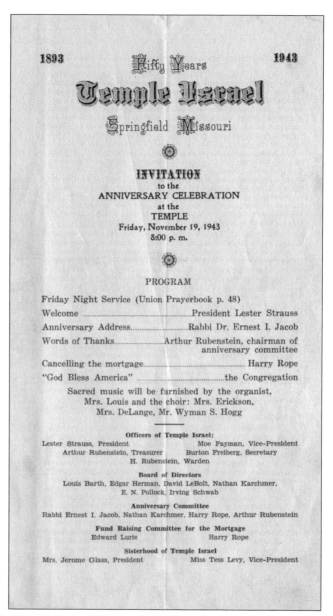

1893 Fifty Years 1943

Temple Israel
Springfield Missouri

◉

INVITATION
to the
ANNIVERSARY CELEBRATION
at the
TEMPLE
Friday, November 19, 1943
8:00 p. m.

◉

PROGRAM

Friday Night Service (Union Prayerbook p. 48)

Welcome ..President Lester Strauss

Anniversary Address.....................Rabbi Dr. Ernest I. Jacob

Words of Thanks..................Arthur Rubenstein, chairman of anniversary committee

Cancelling the mortgage.................................... Harry Rope

"God Bless America"the Congregation

Sacred music will be furnished by the organist,
Mrs. Louis and the choir: Mrs. Erickson,
Mrs. DeLange, Mr. Wyman S. Hogg

———

Officers of Temple Israel:
Lester Strauss, President Moe Fayman, Vice-President
Arthur Rubenstein, Treasurer Burton Freiberg, Secretary
H. Rubenstein, Warden

Board of Directors
Louis Barth, Edgar Herman, David LeBolt, Nathan Karchmer,
E. N. Pollock, Irving Schwab

Anniversary Committee
Rabbi Ernest I. Jacob, Nathan Karchmer, Harry Rope, Arthur Rubenstein

Fund Raising Committee for the Mortgage
Edward Lurie Harry Rope

Sisterhood of Temple Israel
Mrs. Jerome Glass, President Miss Tess Levy, Vice-President

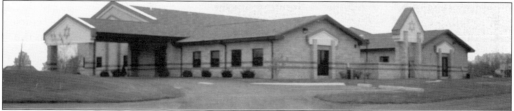

Eventually, the community found the original building too small and in need of costly repair. Therefore, it bought land in Rogersville, Missouri (just outside of Springfield), in 1990 and erected this building. The congregation owns much land around the building that it rents out to farmers to help support the congregation. (Courtesy of the Telling Traditions Project.)

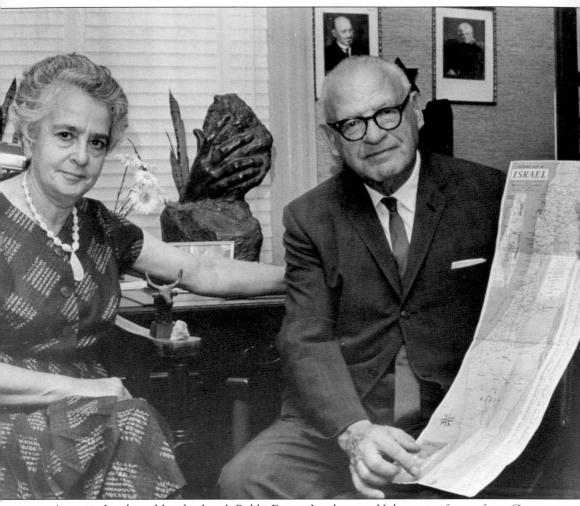

Annette Jacob and her husband, Rabbi Ernest Jacob, were Holocaust refugees from Germany who arrived in 1938. He led the congregation for 25 years. Additionally, both taught (he history and she German) at Drury University. Here, Rabbi Jacob holds a map of Israel as they discuss a pilgrimage they had made to the Holy Land in the summer of 1967. (Courtesy of the *Springfield News-Leader*.)

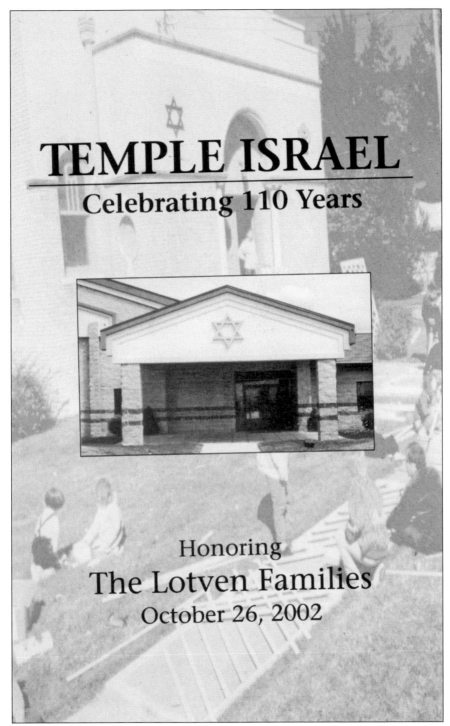

TEMPLE ISRAEL
Celebrating 110 Years

Honoring
The Lotven Families
October 26, 2002

In 2002, Temple Israel celebrated its 110th anniversary with a dinner and dance to honor the Lotven family, which had been part of and profoundly affected the Jewish community since 1912. All of the Lotvens had done their part in serving the Jewish community in both formal and informal roles. (Courtesy of Temple Israel.)

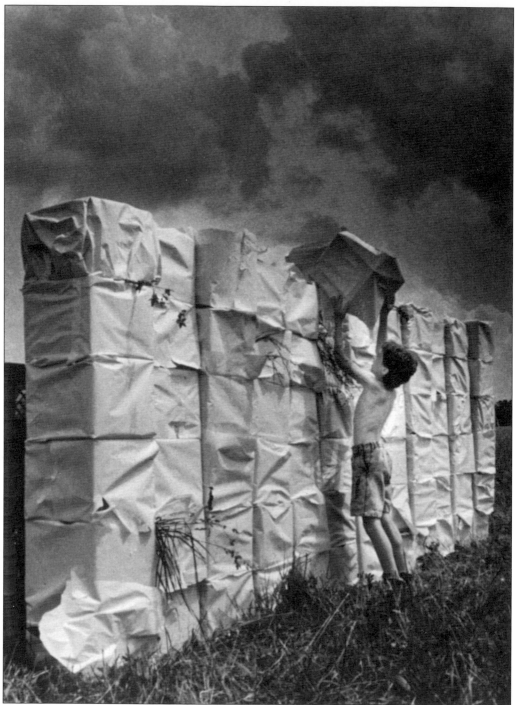

The Jews make their history meaningful by recreating it. In the spring of 1991, nine-year-old Noah Diamond, son of Rabbi Bruce Diamond, is working on a replica of the Wailing Wall, the one remaining wall of the Second Temple in Jerusalem, which is a major pilgrimage destination for Jews. In place of stones, Noah uses milk crates covered in plastic. (Courtesy of the *Springfield News-Leader*, photograph by Jim Mayfield.)

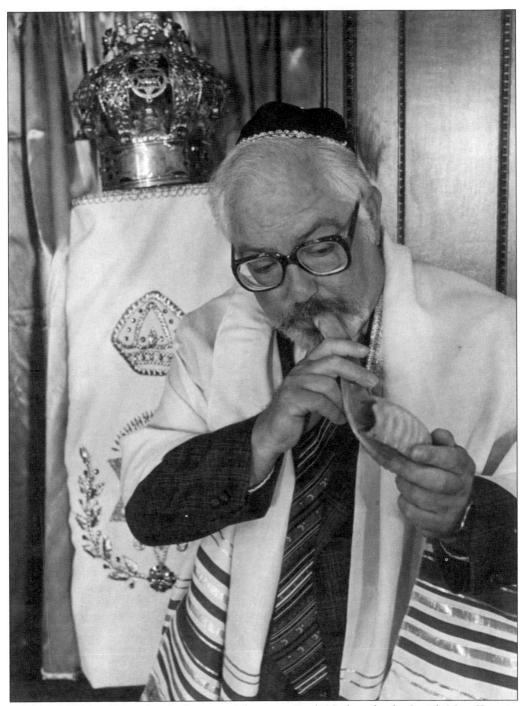

Rabbi Sol Kaplan blows the shofar, a ram's horn, on Rosh Hashanah, the Jewish New Year, in 1980. Blowing the shofar reminds Jews of the start of this 10-day holy season, which ends with Yom Kippur, the Day of Atonement. Kaplan wears the traditional tallit (prayer shawl) and *keepah* (cap) and stands in front of the ark in which the various Torah scrolls are kept. (Courtesy of the *Springfield News-Leader*.)

The current Temple Israel choir, founded by Stefan Broidy and Kenneth Burstin in the early 1980s, is composed of congregational volunteers of all ages who give their voices and their time to make the services more beautiful. The institution of choirs in Jewish services was first raised in 1817 and was based on Biblical references. They have since become a standard part of Reform and Reconstructionist worship, though other movements do not approve of them. (Courtesy of Mara W. Cohen Ioannides.)

Sukkot, or Feast of Booths, is the fall harvest festival. Jews erect an open booth and eat in it for the duration of the festival. Here, Rabbi Rita Sherwin (far left) shares a meal with Sunday school students in the early 1990s. (Courtesy of Temple Israel.)

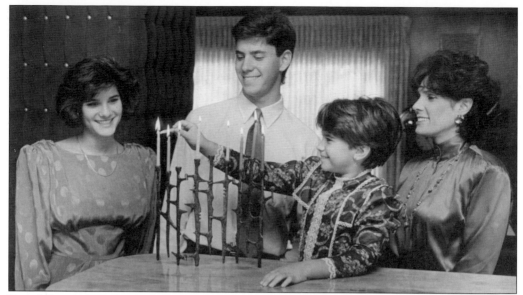

From left to right in December 1986, Lauren, Alan, Jill, and Joan Rosen light the special menorah for Hanukah, the winter holiday celebrating the Maccabean triumph over the Greeks in 165 BCE. The holiday lasts for eight days; each day one more candle is lit until the entire menorah is ablaze. (Courtesy of the *Springfield News-Leader.*)

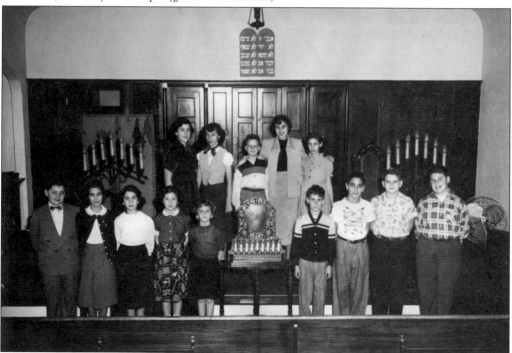

Hanukah is also celebrated in the religious school. Posing in the sanctuary with the community Hanukah menorah in 1950 are, from left to right, (first row) Nick Weinsaft, Edna Mae Farbstein, unidentified, Eleanor Tarrasch, Francie Rosen, David Tarrasch, Robert Deutsch, Mark Rosen, and Alan Arbeitman; (second row) Rosalie Bluestein, Joan Forbstein, Shelly Wallerstein, Nadine Arbeitman, and Phyllis Ann Goldberg. (Courtesy of Nadine Arbeitman Smith.)

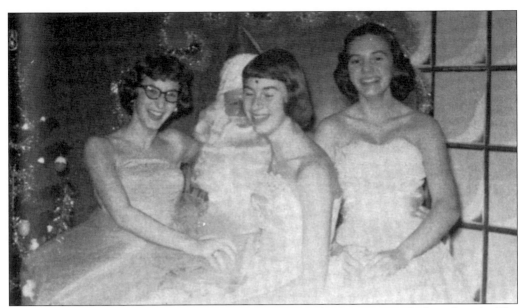

While Jews do not celebrate Christmas, they do join in the festivities with their friends. The Spinners, a singing group at Greenwood Laboratory School, sang at the Heer's Department Store to celebrate the winter season. From left to right, Francie Rosen, with Martie Woodside and Saunny Burks, took time to visit with Santa in the late 1950s. (Courtesy of Missouri State University's Greenwood Laboratory School yearbook.)

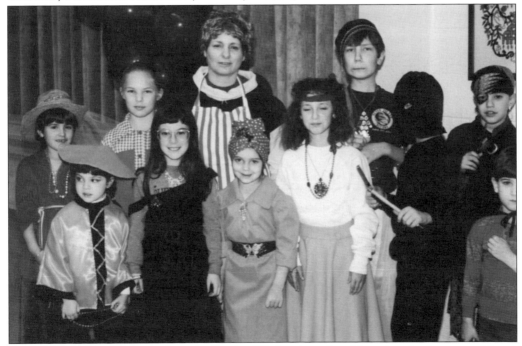

Purim is the spring festival when the Book of Esther is read and is a time for Jews to celebrate freedom and diversity. To commemorate Esther's hidden identity, Jews dress in costume and hold parties to celebrate their survival. Here are the synagogue children in the mid-1990s. (Courtesy of Temple Israel.)

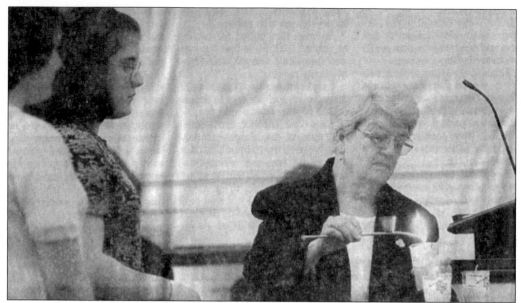

In 1951, a new holiday entered the Jewish calendar: *Yom Hashoah* (Holocaust Remembrance Day). It occurs on the anniversary of the Warsaw Ghetto Uprising. Here Gytel Lotven, a refugee, lights a candle in memory of the six million Jews who died. Observing are, from left to right, Meredith and Stephanie Burstin. (Courtesy of the *Springfield News-Leader*, photograph by Christina Dicken.)

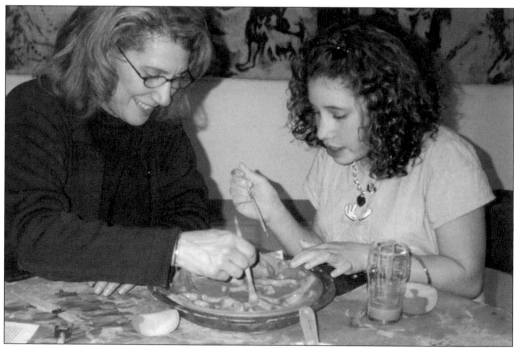

Marla Marantz and her daughter Elizabeth Salzman create a Seder plate, which holds all the required ritual foods for the Passover ceremony, at Temple Israel. Passover is the spring holiday celebrating the biblical Exodus story. Joel Waxman organized this activity with Springfield Pottery for the members of the congregation in 2004. (Courtesy of the Telling Traditions Project.)

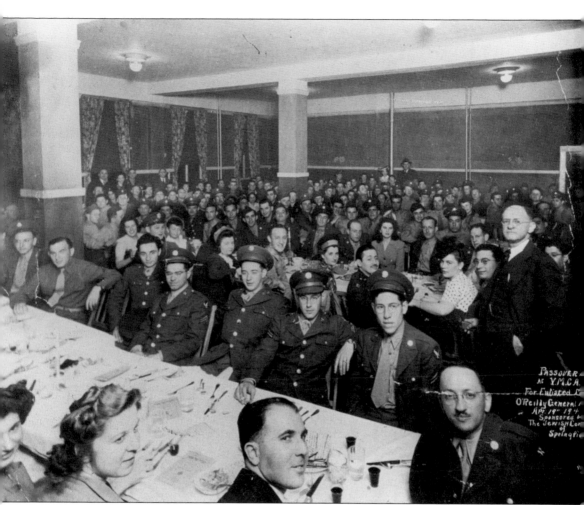

Passover, the holiday marking the ancient Jews' escape from slavery in Egypt as told in the book of Exodus, is an important festival in Judaism. In 1943, the Jewish community of Springfield hosted a Seder (the ceremony for Passover) for soldiers, nurses, and their families at O'Reilly Hospital in the YMCA. On the tables are haggadot (the books containing the service), a plate of matzah (the unleavened bread Jews eat for the eight days of the holiday), and glasses of wine. The Jewish community reached out to the members of the O'Reilly Jewish community regularly, offering them an assortment of services. (Courtesy of the History Museum for Springfield–Greene County.)

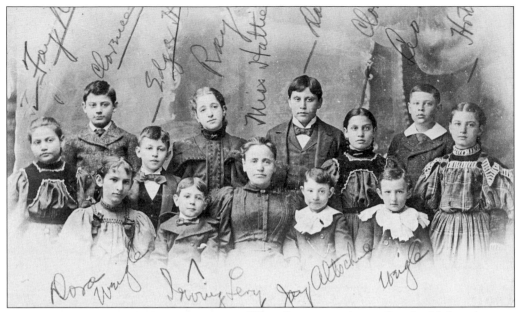

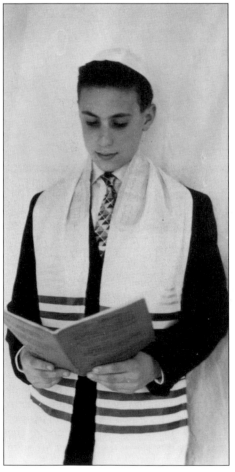

When Jews stopped attending Jewish-based religious schools because public school was available, the Sunday school, based on the Christian model, became popular. First instituted by Rebecca Gratz in Philadelphia, the practice was soon found in every American synagogue. Jews have Sunday schools because on their Sabbath, Saturday, no work is allowed, including teaching. The first Sunday school class in Springfield was started in 1893, just after the first Reform congregation was formed. Edgar Herman, Dan Scharff, and others in this photograph became important members of the Jewish community. Others, like Clara Hirsch, were only in the community for a short time. Seen in this 1893 class photograph are, from left to right, (first row) Dora Weigle, Irving Levy, Jay Altschul, and Hattie Weigle; (second row) Fay Netter, Clarence Scharff, Edgar Herman, Ray M., teacher Hattie Cohen, Dan Scharff, Clara Hirsch, Leo Ellenberg, and Hortence Herman. (Courtesy of the History Museum for Springfield–Greene County.)

Tony Tarrasch, the son of German refugees, celebrated his becoming a bar mitzvah (son of the Commandments) in the mid-1950s, just as boys have for centuries. This ceremony marks the moment when a Jewish boy becomes a man and can, therefore, be counted on to be a witness at a trial or lead the community in prayer. (Courtesy of the History Museum for Springfield–Greene County.)

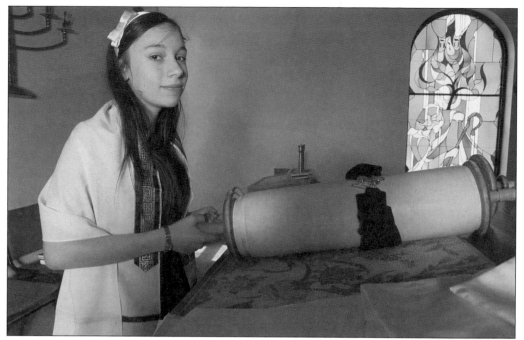

Sasha Cohen Ioannides is photographed in 2011 preparing to read the Torah as she becomes a bat mitzvah (daughter of the Commandments). The bat mitzvah ceremony is new to Judaism, dating to the 1920s. Traditionally, women have not been allowed to touch the Torah or lead the prayer service. Today, all sects of Judaism have some kind of bat mitzvah ceremony. (Courtesy of Mara W. Cohen Ioannides, photograph by Stormy Bultas.)

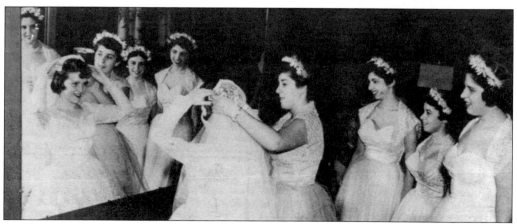

In Judaism, marriage is a contract between two people. In this image, Miriam Wallerstein (seated) is preparing to marry Lt. H. Jack Bluestein. Also visible are, from left to right, Rosalie Bluestein (the groom's sister, helping with the headpiece), Helene Cohn, Ina Mae Frankel, and Shirley Sass. This wedding, in the Kentwood Arms Hotel on July 4, 1953, was listed as "one of the largest and loveliest of the summer season" in *Bias* magazine. (Courtesy of the History Museum for Springfield–Greene County.)

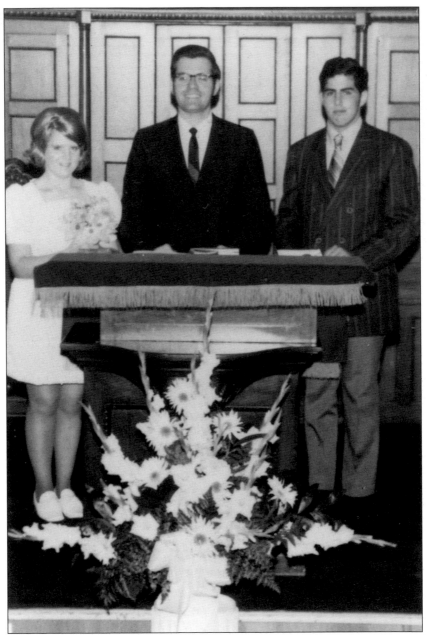

Standing from left to right, Rosemary Rubenstein, Rabbi David Wucher, and Bernard Kramer celebrate Rosemary and Bernard's confirmation in the spring of 1970. Confirmation, or graduation from religious school, was instituted by the Reform Movement in 1817 and was meant to parallel a bar mitzvah for girls. It was also devised to be like the Protestant confirmation so that Jewish children would feel they were having experiences similar to those of their Christian neighbors. As the bat mitzvah became more popular, confirmation became less fashionable among Jews. Currently, it has become a milestone for youths in their Jewish education. Rabbi Wucher was a student rabbi for the congregation from 1975 to 1978 and returned in 1983 for a few years as the full-time rabbi. During this time, he also taught at Missouri State University. (Courtesy of the History Museum for Springfield–Greene County.)

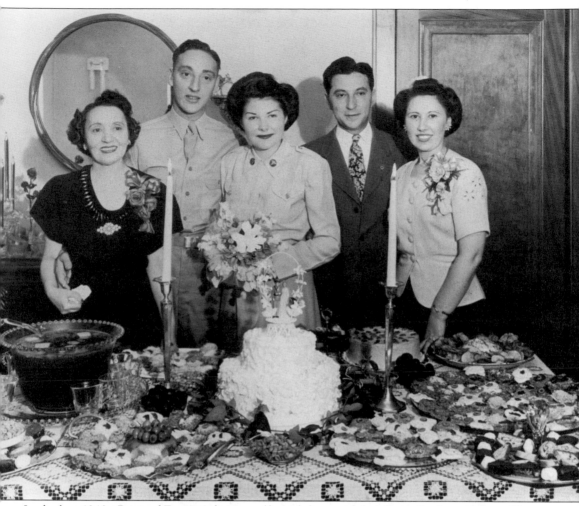

In the late 1940s, Ben and Fanny Arbeitman (far right) opened their home for the wedding of Jay Kochman, a soldier recovering at O'Reilly Hospital, and his bride, Gertrude, a nurse at the hospital. Mrs. Kochman (far left) and her daughter (not shown), visiting from Memphis, were the couple's only family there. The community provided the refreshments. The Kochmans became lifelong friends of the Arbeitmans. (Courtesy of the History Museum for Springfield–Greene County.)

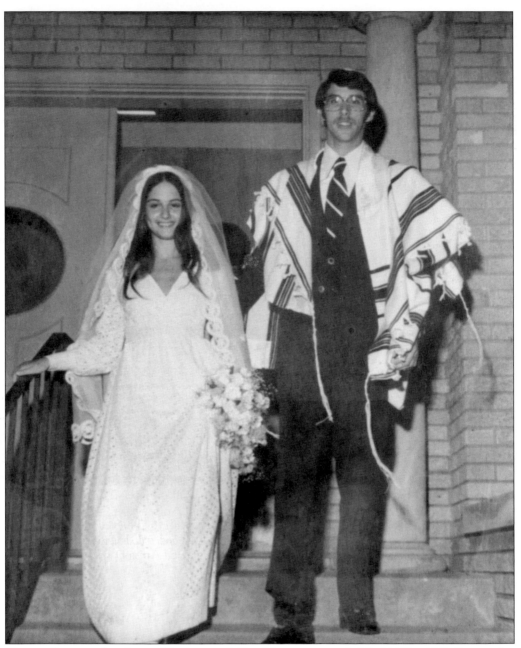

Simone Lotven, daughter of Isadore and Gytel Lotven, married Rabbi David Sofian at the first synagogue in Springfield, sometimes referred to as the "Community Center." Simone later became a member of the editorial board of the Union of American Hebrew Congregations Press, a scholar on Jewish literature, and an advocate for Jewish causes, taking after her extended family's involvement in the Jewish community both locally and nationally. David received his ordination from Hebrew Union College and served congregations in Lancaster, Pennsylvania; Chicago, Illinois; and Dayton, Ohio, and is a well-respected scholar of Torah and Talmud. (Courtesy of Gytel Lotven.)

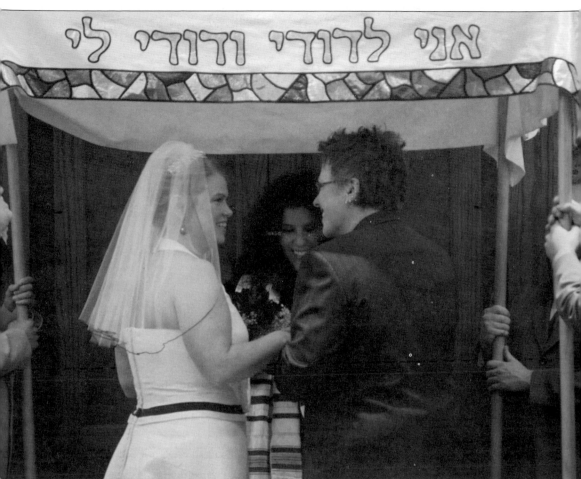

אני לדודי ודודי לי

The Reform Movement approved homosexual marriage in 2000. The first such ceremony in Springfield was the 2008 wedding of Billie Marsala (left) and Anisa Dawn (right). Rabbi Rita Sherwin performed the ceremony as four friends held the chuppah (wedding canopy), signifying their home. On the chuppah is a line from Song of Songs: *Ani l'dodi v'dodi li*, meaning "I am my beloved's and my beloved is mine." (Courtesy of Billie Marsala and Anisa Dawn, photograph by Robert E. Anderson, III Photography.)

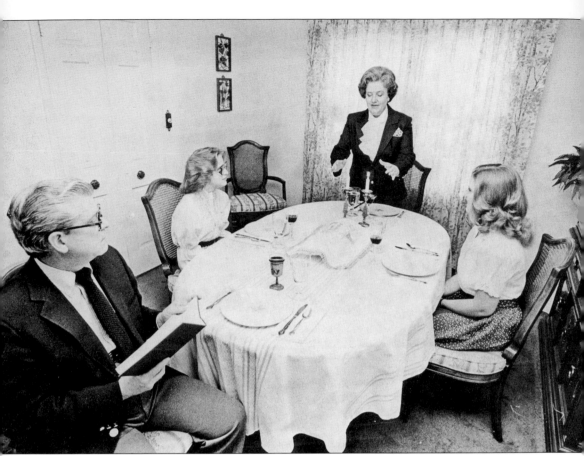

One of a married woman's religious obligations is the blessing of the Sabbath candles. Three objects are needed to start the Sabbath, beginning Friday at sundown: candles, bread (seen here under a special cover), and wine. George Rubenstein waits to bless the wine until his wife Darlene finishes blessing the candles as their daughters, Julie (left) and Rosemary (right), look on during this lavish 1980 Sabbath dinner. (Courtesy of the *Springfield News-Leader*.)

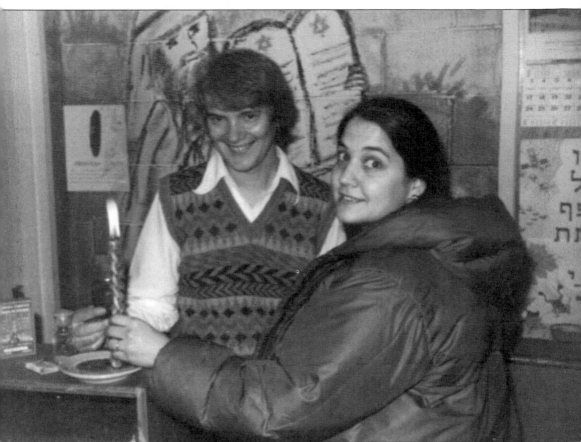

Nancy Cooper and Mindy Kaplan (daughter of Rabbi Sol Kaplan) prepare for the celebration of havdalah, which marks the end of Shabbat, in 1980. The ceremony uses the braided candle representing the unity of the Jews, a spice box containing spices traditionally used in Sabbath meals, and a glass of wine. (Courtesy of Temple Israel.)

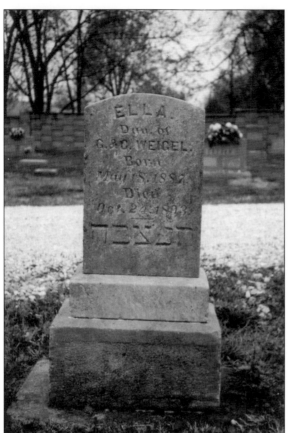

Ella Weigel, the first person buried in the Jewish cemetery, was laid to rest in 1893, the same year the Reform congregation organized. This six-year-old girl was the daughter of George (or "Goodman") and Catherine Weigle. (Courtesy of Mara W. Cohen Ioannides.)

Cemeteries were the first purchase of New World Jews. Since Jews do not need consecrated ground in order to worship, they would gather in the largest home in town or, for special observances, rent the community ballroom. They do, however, require consecrated ground to bury their dead. The Jewish cemetery in Springfield opened in 1893; before this, Jews were buried in Hazelwood Cemetery, which is located just to the east of Temple Israel's cemetery. The gate's arch was lost at some point in the 20th century, and a stone marker on the gate now provides the name of the cemetery. (Courtesy of Rosemary Rubenstein.)

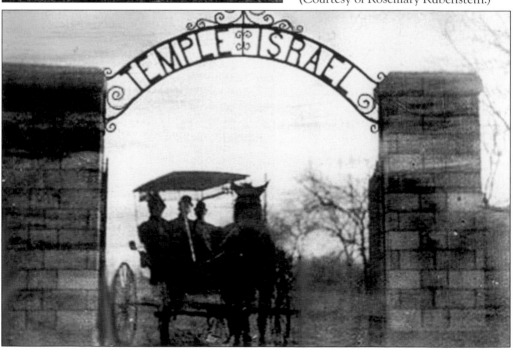

Two

BUSINESS

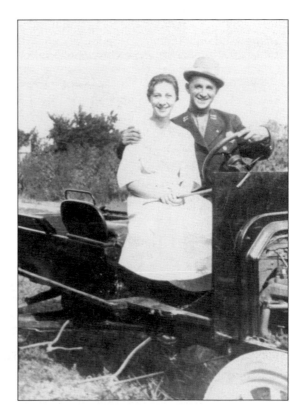

Ben Moskowitz and Lottie Nichols, who were neighbors growing up, married at the end of World War I at Camp Funston in Kansas. When Ben was honorably discharged from the US Army, they moved back to Springfield. Ever involved with cars, Ben opened the National Auto Company, which he ran until his death in 1930. Lottie raised their five daughters on her own while also taking over the business; with the help of the staff, she became the most powerful businesswoman in Springfield. (Courtesy of Mary Moskowitz Watters and Jim Watters.)

TRADE PALACE.

VICTOR SOMMERS & CO.

Wholesale and Retail Dealers in

DRY GOODS, CLOTHING, BOOTS, SHOES, HATS, NOTIONS

GENTS' FURNISHING GOODS,

N. W. CORNER PUBLIC SQUARE, IN CITY HALL BUILDING

Victor Sommers landed in New Orleans in 1853 with his parents and went to Louisville, Kentucky. In 1868, he opened the first Jewish-owned business in Springfield. In 1869, he brought his new bride, Bertha Bakrow, from Louisville, Kentucky, to Springfield. They were joined by her brother Ferdinand Bakrow and cousin Richard Beckrow. The couple eventually went to live with Bertha's sister and brother-in-law Rosa and Moses Mendel in Hot Springs, Arkansas. (Courtesy of Greene County Archives.)

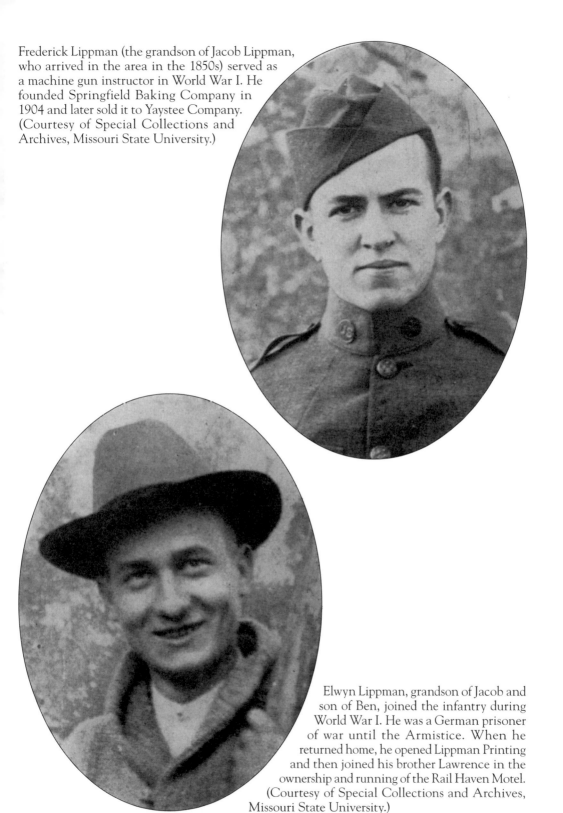

Frederick Lippman (the grandson of Jacob Lippman, who arrived in the area in the 1850s) served as a machine gun instructor in World War I. He founded Springfield Baking Company in 1904 and later sold it to Yaystee Company. (Courtesy of Special Collections and Archives, Missouri State University.)

Elwyn Lippman, grandson of Jacob and son of Ben, joined the infantry during World War I. He was a German prisoner of war until the Armistice. When he returned home, he opened Lippman Printing and then joined his brother Lawrence in the ownership and running of the Rail Haven Motel. (Courtesy of Special Collections and Archives, Missouri State University.)

The Rail Haven Motel, now in the National Register of Historic Places, was built in 1938 by Lawrence and Elwyn Lippman. The original cottages were constructed of Ozark stone. Elwyn, Lawrence, and Katherine (Lawrence's wife) sold the hotel and retired in 1961. During its heyday,

the hotel hosted notable guests, such as Elvis, whose mother preferred it to the more expensive hotels in town. (Courtesy of Jerry Rice.)

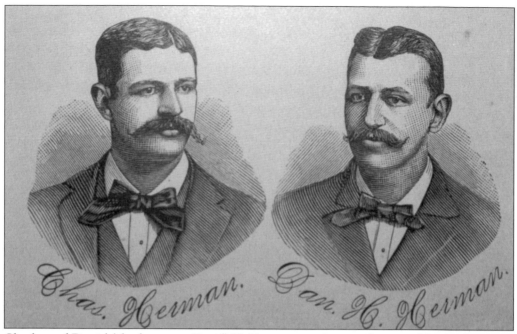

Charles and Daniel (also known as David) H. Herman were born in Syracuse, New York. Daniel and his wife, Nellie, arrived first in Springfield in 1880. Charles followed within the next two years, and the two went into business together. Daniel continued the business with branches in Lamar, Joplin, and St. Louis, among other towns; Charles eventually returned east. (Courtesy of *History of Greene County: 1883*, Springfield–Greene County Archives.)

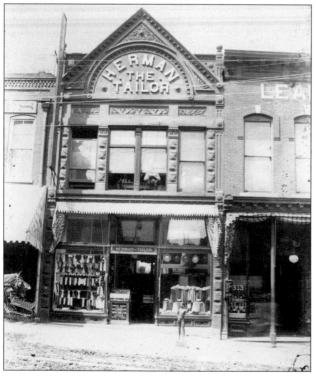

Herman the Tailor, run by Charles and Daniel Herman, was at 324 and 326 St. Louis Street, near Robberson Avenue, just off the Public Square. D.H. Herman's One Price Clothing House opened in 1880 with a certain degree of pizzazz; Daniel hired a brass band and bought a full-page advertisement in the local paper. The store, seen in this c. 1900 photograph, was considered quite grand by the local population and was known for serving clients from as far away as St. Louis. After Charles left Springfield and Daniel retired, the business was taken over by Daniel's son Edgar. (Courtesy of the History Museum for Springfield–Greene County.)

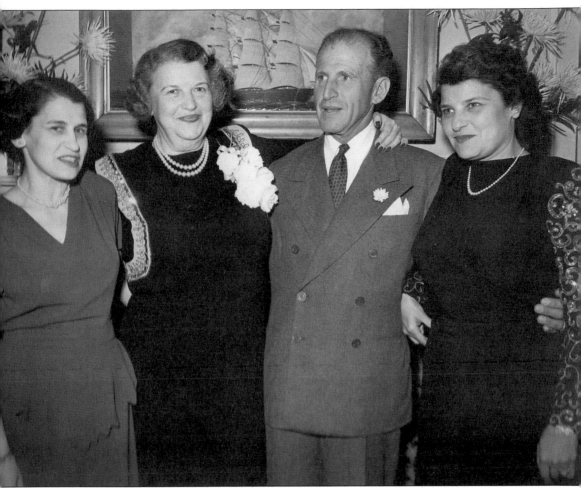

Daniel and Nellie Herman had four children: Blanche, Hortense, Edgar, and Ruth. The Herman family was quite wealthy, sending Blanche to high school in St. Louis. Edgar inherited the store, and he stayed with it despite being courted by companies on the east coast. Hortense married Nathan Rose of the Rose Brothers Fur Company in St. Paul. (Courtesy of Bob Lebherz.)

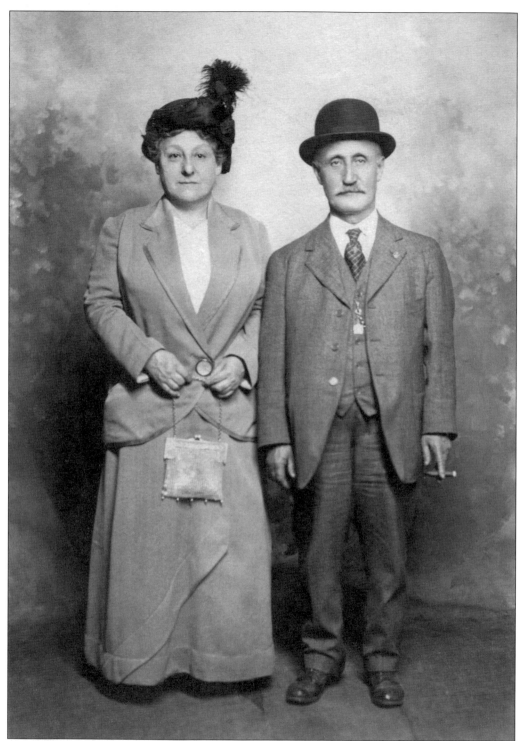

Francis (Cohn) Marx (left) and Jake Marx met while living in Louisville, Kentucky, and were married in 1877. They had no children of their own but adopted Rachel Cohn, a cousin of Francis. (Courtesy of Donald L. and Linda P. Cohn.)

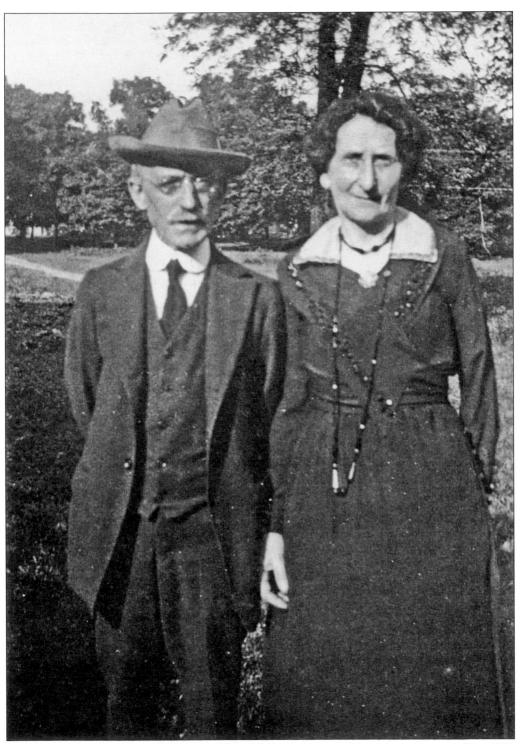

Gus Marx, Jake's brother, and Hannah (Cohn) Marx, a cousin of Francis, were married in 1885. Gus and Jake were partners in the Marx brothers' store. Two of Gus's sons, Emmanuel "Manny" and Arthur Sr., inherited the business when Gus died. (Courtesy of Donald L. and Linda P. Cohn.)

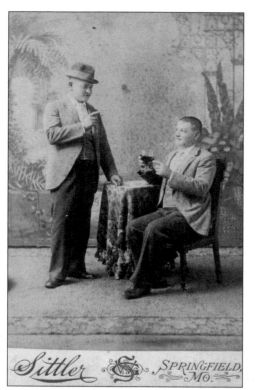

This playful photograph, on which two images of Herman Cohn are superimposed, is highly unusual, as was the man himself. In the late 1880s, Herman left Louisville, Kentucky, and joined his sister and brother-in-law Hannah and Gus Marx in Springfield, where he worked in the Marx brothers' store. He returned to Louisville after marrying Mamie Reister but came back to Springfield around 1912, when his illness became too difficult for his wife and son to deal with. He spent the rest of his life in and out of an asylum in Nevada, Missouri, where he eventually died. (Courtesy of Donald L. and Linda P. Cohn.)

In 1878, Jake Marx arrived in Springfield and worked for his brothers-in-law at the Cohn Bros. & Co. store. Shortly thereafter, he bought them out and ran the business until his death in 1928. This image is believed to show the grand opening of his store, with Jake Marx standing third from the left. (Courtesy of Madelynn Marx Inness.)

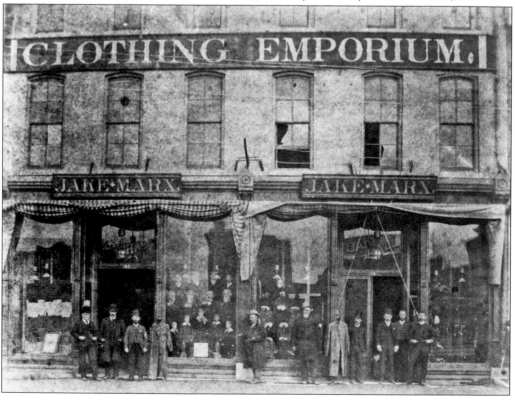

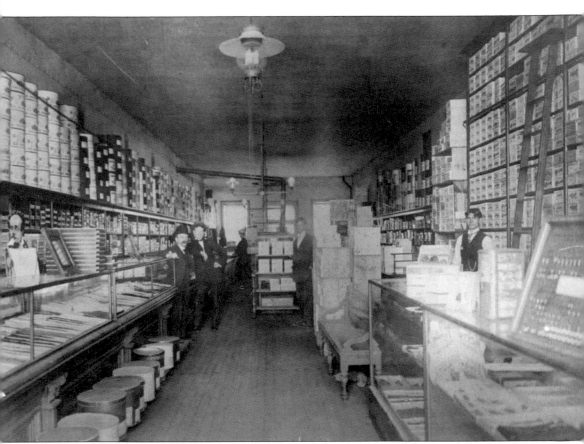

This interior photograph could have been taken for the grand opening of the store. The Marx Clothing Company was funded by Francis Marx, Gus Marx, Julius Cohn, H.F. Star, Abe Bloom, and T.J. Delaney. (Courtesy of Madelynn Marx Inness.)

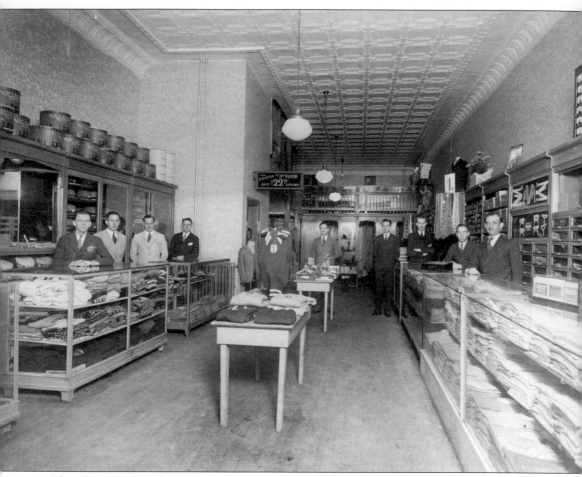

This photograph of the store's interior from the early 1930s was most likely taken for the business's 50th anniversary. Standing are, from left to right, Al McBarvey, Wilson Raidler, Lee Tisdale, Milton Skillens, Art Marx Sr., Dave McKnight (?), John Pickering (?), Bud Banks, and Manny Marx. (Courtesy of Madelynn Marx Inness.)

This 1940s photograph includes Arthur Marx Sr. (Jake Marx's nephew, second from right), Arthur Marx Jr. (third from right), and Manny Marx (fourth from right). The Marx Clothing Company remained open at the same address on Park Central East, with Arthur Marx Jr. retiring in the latter part of the 20th century. (Courtesy of Madelynn Marx Inness.)

Morris and Hannah Evelyn Moskowitz moved from St. Louis to Springfield with their children in the early 1880s and opened a grocery on West Nichols Street. Morris was instrumental in getting the Orthodox congregation organized. In 1917, Hannah died of kidney failure while visiting family in St. Louis. Morris packed up, went back to St. Louis, and died only three years later. Only their sons Ben and Teddy stayed behind in Springfield. (Courtesy of Mary Moskowitz Watters and Jim Watters.)

Marx Netter was living in New Orleans when he got a job with Max Scharff, who owned stores in both New Orleans and Springfield. He married his employer's daughter Fay and moved to Springfield, where he opened Netter's at the beginning of the 20th century. (Courtesy of Drury University.)

J. D. LEBOLT

THE CIGAR
MAN

▭

HIGH GRADE CIGARS
AND PIPES

▭

PIPE REPAIRING

LOBBY WOODRUFF BUILDING

The LeBolt families of Springfield, Missouri, and Springfield, Ohio, can be traced back to two brothers. In 1882, Gus LeBolt of Ohio came to Springfield, Missouri, where he worked for a time in a dry goods store. He later bought out a cigar business. His brother Abraham came later to Springfield, where he married Della Levy, heiress to the Model/Levy-Wolf department store. (Courtesy of Central High School.)

In 1888, Moses Levy opened the Model Dry Goods Company; the store changed names in 1914 to incorporate the inclusion of Moses's nephew-in-law Solomon R. Wolf, who originally was in business in Sedalia, Missouri. For a short time, the Model was owned by Simon Levy, the uncle of Abraham's wife, Della Levy. (Courtesy of Drury University.)

Irving R. Levy, the son of Moses and Henriette Levy, was only in the family business for a short time. His father, uncle (Simon Levy), and brother-in-law (Abraham LeBolt) all worked at Model (later called Levy-Wolf), and after serving in World War I, Irving was the treasurer of the company. (Courtesy of the History Museum for Springfield–Greene County.)

Mildred LeBolt, daughter of Abraham LeBolt and Della Levy, became the secretary-treasurer of the Levy-Wolf Department store in 1946, when her cousin Minnie W. (Wolf) Hirsch died. She lived with her brother David and aunt Tess R. Levy and was a longtime member of the synagogue Sisterhood. (Courtesy of Central High School.)

David LeBolt, son of Abraham LeBolt and Della Levy, became president of the Levy-Wolf Department Store when his cousin Minnie W. (Wolf) Hirsch died in 1946. A graduate of Springfield High School and the University of Missouri, he lived in Fredericksburg, Virginia, and in New York City, where he worked in two different department stores. This is a photograph on the occasion of his 50th birthday in 1950. (Courtesy of the History Museum for Springfield–Greene County.)

The second building from the left in this 1920s photograph is the Levy-Wolf Annex on the Springfield Square. Levy-Wolf was on the square for over 60 years. It was well known for its customer service, which included custom tailoring. (Courtesy of the History Museum for Springfield–Greene County.)

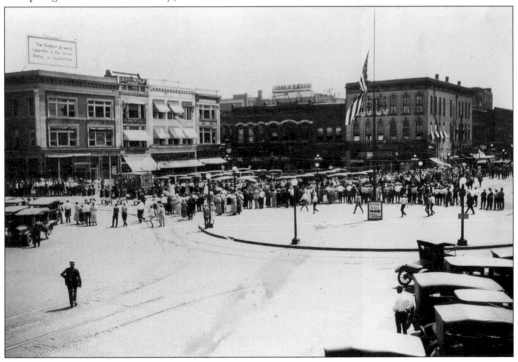

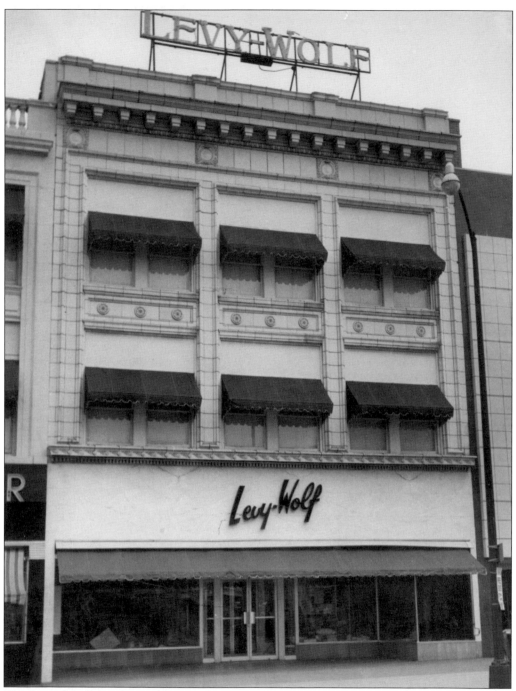

The last president of Levy-Wolf was Coleen LeBolt, wife of David and daughter-in-law of Abraham and Della. She closed the store in 1981 because she could not compete with the newly opened mall. The building is now rented by Missouri State University. (Courtesy of Doug and Denise LeBolt.)

Joe Rubenstein (here in 1940), a rabbinical student, was smuggled out of Lithuania by his parents to avoid military service. He ended up living with a sister in Illinois. In 1894, Joe's brother-in-law Nathan B. Nathan asked him to come to Greenfield to open a business. Joe complied, and his store, Rubenstein's, became known as Dade County's Greatest Store. Despite the distance, the Rubensteins attended both congregations in Springfield and shopped at Lipman's grocery. (Courtesy of Rosemary Rubenstein.)

Max Schwab fled Germany to escape from Bismarck's army, arriving in 1884 in New York City, where he worked in the Garment District. He came to Springfield from New York in 1904. Max's brother David arrived in 1886 after fleeing their father's house; he worked in Kansas City before joining Max. The two ran Schwab's Clothing (seen here behind Kieffer & Hawkins around 1908). Max was known as a great salesman and his brother as a no-nonsense guy. The brothers each had one child; Max had a son, Irving, while David was father to Dorothy. (Courtesy of the History Museum for Springfield–Greene County.)

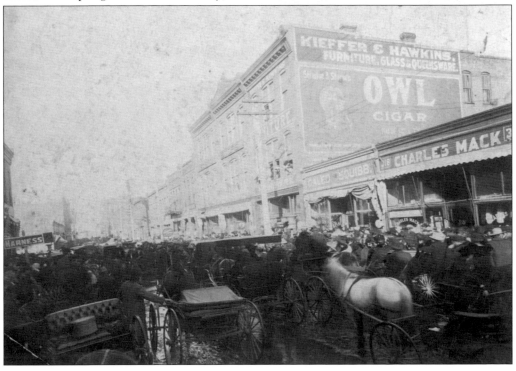

Irving Schwab was an attorney for 50 years in Springfield and also taught courses at Missouri State University. He graduated from Drury University in 1919. During his years as an attorney, he was the only Jewish lawyer in Springfield. He served a term as president of the synagogue, although he rarely attended services. (Courtesy of Drury University.)

Fred Lippman, the son of Jacob Lippman, founded the Springfield Baking Company in 1904. He remained the treasurer and secretary, and his brother-in-law Samuel L. Eslinger was the president. The company was later sold to the Yaystee Company. (Courtesy of the History Museum for Springfield–Greene County.)

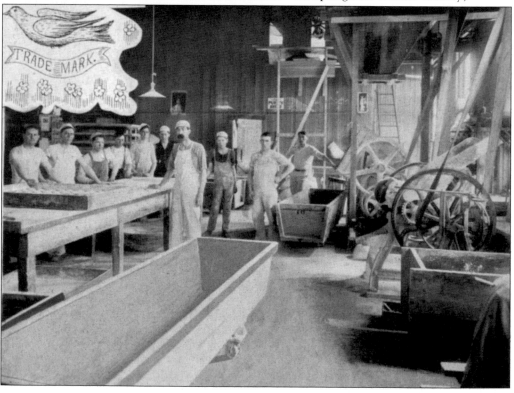

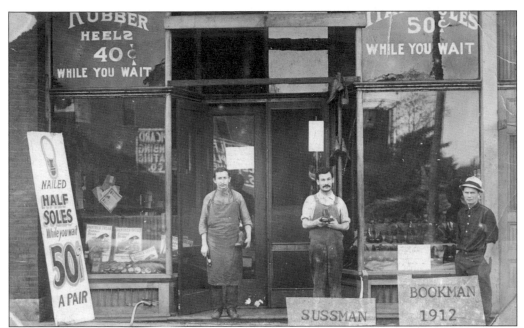

In 1912, Israel Lotven arrived in the United States, having left his wife, daughter, and four sons in Russia. Julius Bookman already had his shoemaking business open in Springfield. Ben Sussman, who arrived in the United States in 1910 from Poland, was the manager of the store; he met his wife, Eva, in this country. Israel had been a shoemaker in Russia and was readily welcomed not only into the business but also into the Orthodox Jewish community. Eventually, Israel opened his own business, Lotven's Shoe Store & Shoe Repair, at 527 Booneville Avenue. Both he and Sussman were charter members of Sha'are Zedek. (Courtesy of Regina Lotven.)

Benjamin "Ben" and Lillie Nudelman Ellman arrived in Springfield around 1920. Before arriving in Springfield, Ben traveled for business. He was charter member of Sha'are Zedek and had a number of businesses in town, including a liquidation company. (Courtesy of Marlita Wennerman Weiss.)

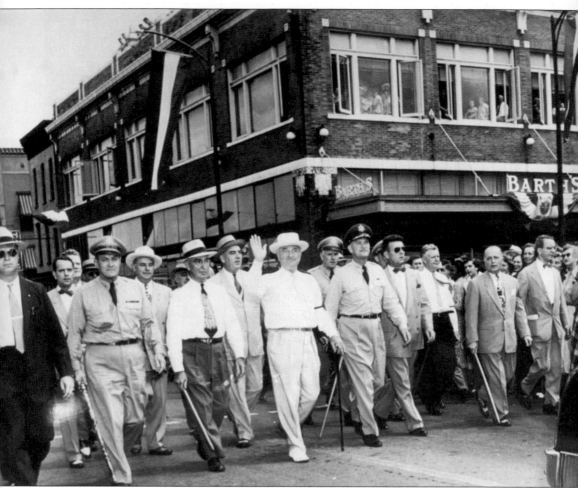

Pres. Harry Truman, born and raised in Missouri, decided that the 1952 reunion for the World War I 35th Infantry Division should take place in Springfield—the third largest city in the state. He marched in front of the parade as it passed by Barth's Store on the square. Barth's Store was a fixture on the square, originally operating under the name Nathan's. (Courtesy of the History Museum for Springfield–Greene County.)

The Oberman Manufacturing Company was founded in St. Louis by David M. Oberman, an immigrant from East Prussia. David's company produced prison and military clothes, and he opened a manufacturing plant in 1923. Two charter members of the Orthodox Jewish community, Edward Lurie and Isaac Cohen, worked there. (Courtesy of the History Museum for Springfield–Greene County.)

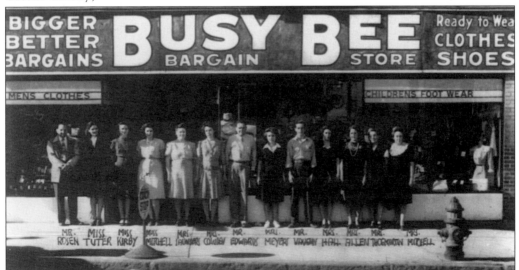

Arthur Rosen (far left) left Germany in 1934 with $20 in his pocket. He arrived in St. Louis to live with an uncle. After working in various Missouri department stores for a number of years, including Famous & Barr (in St. Louis) and Wohl Shoe Company (in both St. Louis and Salem), he was offered the position of manager of the Busy Bee store in Springfield. Eventually, he bought the business and became a well-respected member of the Springfield community. (Courtesy of Special Collections and Archives, Missouri State University.)

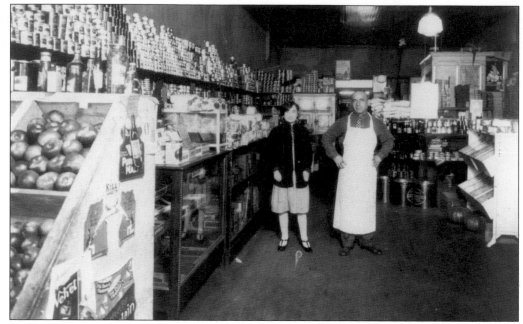

In the 1920s, Rabbi Jacob Lipman opened what was to become the area's longest-operating Jewish-owned grocery, which his son ran until 1954. Since Jacob was also a *shocket*, or "ritual slaughterer," he supplied the community with kosher meat from small animals and would order in kosher beef for his clients. Here are Sonja Lipman Schechler and Ben Lipman in Lipman's Grocery at 657 South Market Avenue in the early 1930s. (Courtesy of the History Museum for Springfield–Greene County.)

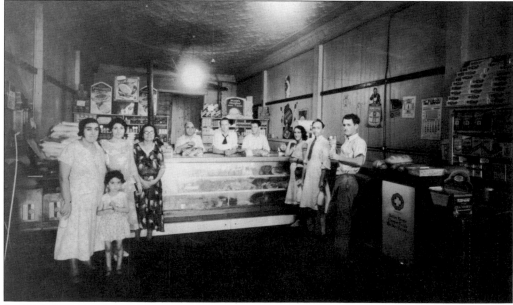

In 1933, Sonja and Ben Lipman took over the business when their father, Jacob, died. Jacob's passing came before he could join his wife in Israel. In this photograph are, from left to right, Rose Lipman, Lorraine Lipman, unidentified, Gert Savanofsky (a cousin), a clerk, "Doc," Ben Lipman, and three unidentified customers. (Courtesy of Lorraine Lipman Raskin.)

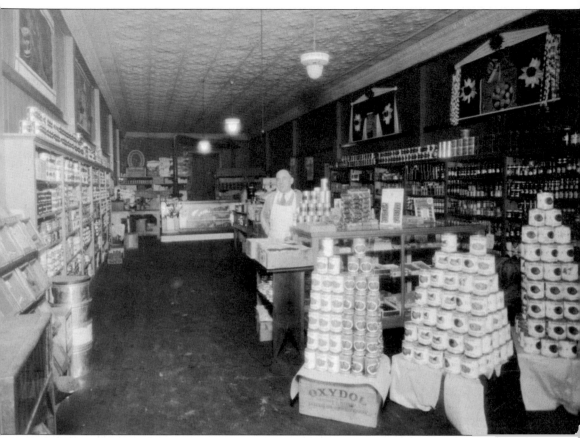

This is the last known photograph of Ben Lipman in his store. By this time, his sister Sonja had moved to Israel, where she married and stayed. When Ben died in 1955, his wife Rose and her cousin Gert Savanofsky ran the business for a number of years before eventually closing it. (Courtesy of Lorraine Lipman Raskin.)

Ben J. Arbeitman arrived in the United States in 1921 and graduated high school in 1929. He worked as a shoe salesman before joining the family business. He later founded Federow Iron and Metal with his father-in-law, Ben Federow. Arbeitman's son-in-law Manny Smith later joined the company. (Courtesy of Central High School.)

Harry Federow attended the Missouri School of Mines, from which he graduated in 1933. He worked for Shell Oil in St. Louis before moving back to Springfield, where he joined the family business, Federow Iron and Metal Company (FimCo), started by his father, Ben Federow. (Courtesy of the Federow family.)

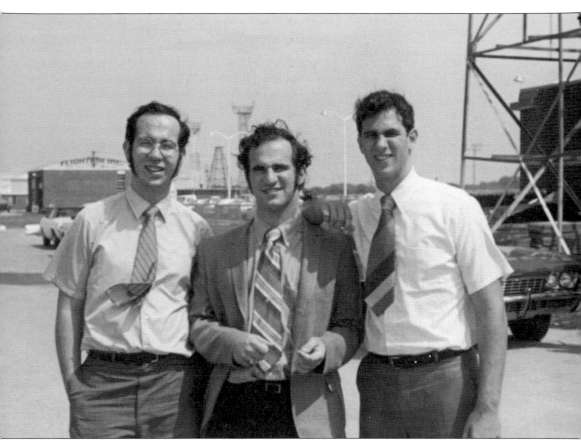

From left to right, Michael, Howard, and Stuart Federow stand outside the Springfield Airport around 1970. They inherited FimCo from their father. Michael has died, and while neither Howard nor Stuart live in the state, they still run the family business through a local manager. (Courtesy of the Federow family.)

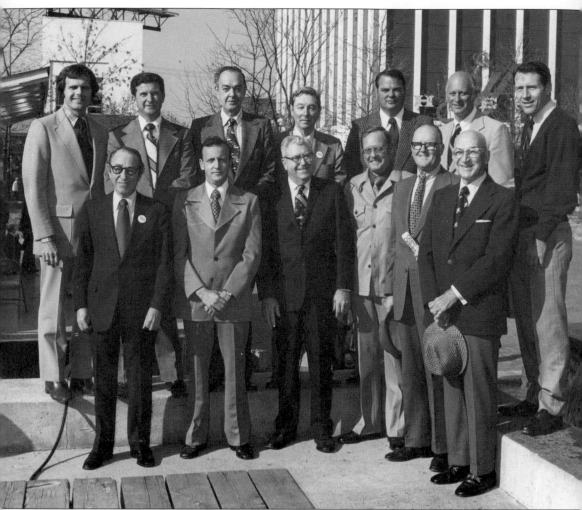

In 1972, the square in Springfield, known as Park Central Square, was dedicated as a pedestrian plaza. David LeBolt (first row at far left), an influential businessman and volunteer for numerous charities, participated in the dedication with a number of other dignitaries. (Courtesy of Doug and Denise LeBolt.)

Three

FOUNDERS AND LEADERS OF THE JEWISH COMMUNITY

Rabbi Jacob Lipman arrived in Springfield in the early 1920s. As the family legend goes, he was sought out and brought to the area by Ben Karchmer to serve not only as rabbi to the Orthodox community but also as a shocket. After arriving in the United States in 1907, Lipman brought his wife, Dora, and eight children to Philadelphia. When he moved to Springfield, he arrived with his four youngest children and Dora. He served as rabbi and shocket until his death in 1933. (Courtesy of Lorraine Lipman Raskin.)

Nellie Herman arrived in 1880 with her husband, Daniel. While her husband and brother-in-law ran the One Price Clothing House and then Herman and Brother, she raised four children. The family was very wealthy and belonged to both Temple Israel (of which Daniel was a charter member) and Temple Israel in St. Louis. Only one of their children attended high school in Springfield; the others were sent elsewhere. (Courtesy of Tom Rose.)

Moses Levy, a founder of the Reform congregation, began the Model Dry Goods Stores in 1888. David and Simon Levy (presumed to be Moses's brothers) also worked in the business, which was eventually renamed Levy's. Moses married David's widow, Henriette, and raised David's children as his. He is seen here with one of his grandchildren in the 1910s. (Courtesy of Doug and Denise LeBolt.)

Della Levy LeBolt was the daughter of David Levy and Henriette Resenheim but was raised by her mother's second husband, Moses Levy. After the early death of her husband, Abraham, she raised her children in her parents' house on Walnut Street. (Courtesy of Doug and Denise LeBolt.)

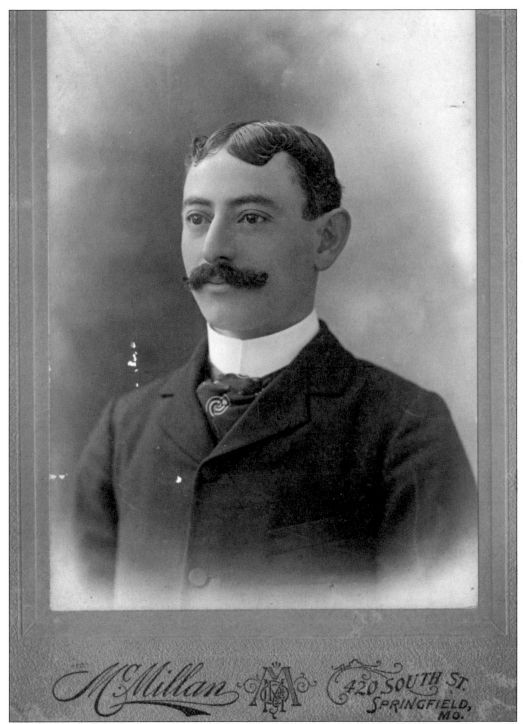

McMillan 420 SOUTH ST. SPRINGFIELD, MO.

Abraham LeBolt, who had come to Springfield at the request of his brother Gus, most likely worked at Moses Levy's store, the Model. He met and married Della Levy, with whom he had three children. He died young, and his nephew Solomon Wolf was invited by Moses to join the firm, which was renamed Levy-Wolf. (Courtesy of Doug and Denise LeBolt.)

After her mother's death, Rachel "Ray" Marx was raised by her cousin Francis Cohn Marx and Francis's husband, Jake. Jake Marx was influential in both the business world and the Jewish community of Springfield. (Courtesy of Donald L. and Linda P. Cohn.)

Nathan Balchowski, later Nathan B. Nathan, convinced his brother-in-law Joseph Rubenstein to move to Greenfield, Missouri. Nathan and his wife left two infants in Temple Israel Cemetery when they moved away. This c. 1900 picture includes four of Nathan and Etta Nathan's children, as well as their cousins Herschel and Arthur Rubenstein (in the wagon), who were active in the Jewish community their father, Joseph, helped found. (Courtesy of Rosemary Rubenstein.)

Max Yoffie was different than all other immigrants to the area in that he was of Spanish descent. His family had left Spain in 1492, fleeing to Holland. In 1893, he arrived in Forrest City, Arkansas, where he co-owned a clothing business. In 1914, he moved his family to Springfield to provide a better environment for his five daughters. After helping to found Sha'are Zedek, he returned to Arkansas in 1928. (Courtesy of Paul Isbell.)

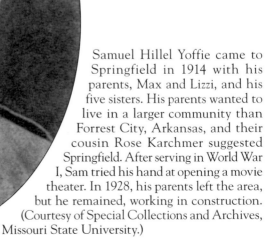

Samuel Hillel Yoffie came to Springfield in 1914 with his parents, Max and Lizzi, and his five sisters. His parents wanted to live in a larger community than Forrest City, Arkansas, and their cousin Rose Karchmer suggested Springfield. After serving in World War I, Sam tried his hand at opening a movie theater. In 1928, his parents left the area, but he remained, working in construction. (Courtesy of Special Collections and Archives, Missouri State University.)

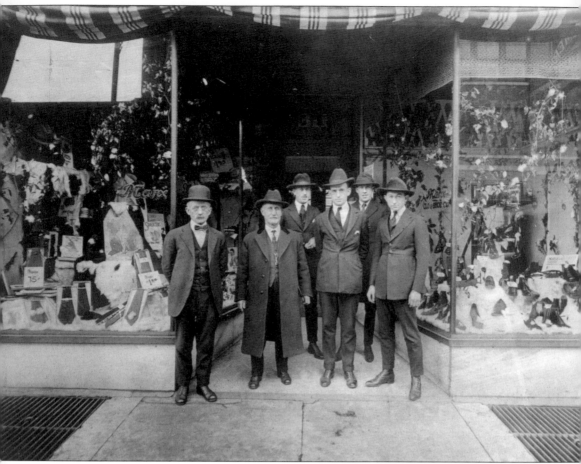

This image, taken between 1916 and 1917, shows, from left to right, Jake and Gus Marx, Gus's sons Arthur and Emmanuel "Manny" Marx, Holland Chalfant, and Gus Bowan in front of the Marx Clothing and Shoe Company at 311 St. Louis Street. Jake was a charter member of Temple Israel, the Reform congregation. Arthur was the last owner of the business, closing it in 1972, a year before he died. (Courtesy of Madelynn Marx Inness.)

Sol Kransberg is the grandson of Fred and Sarah Kransberg and the son of Jake and Anna. His father was a charter member of Sha'are Zedek and worked in the Oberman factory. Sol graduated from Missouri State University. (Courtesy of Missouri State University's *Ozarko Yearbook*, Special Collections and Archives, Missouri State University.)

Louis Sykes, the son of Alfred and Rena (or Lena) Sykes, graduated from Central High School in 1918. Alfred was a charter member of Sha'are Zedek and worked for the Frisco Railroad Company. (Courtesy of Central High School.)

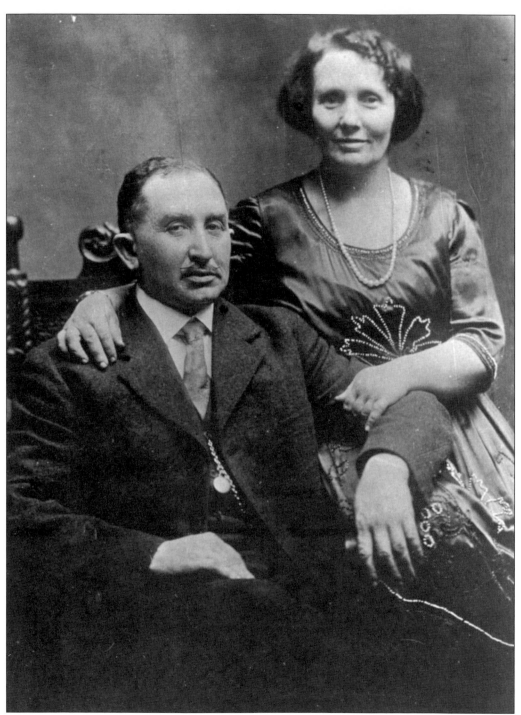

Israel Lotven arrived in Springfield in 1912. Shortly thereafter, his eldest daughter joined him. Almost a decade later, his wife, Jenny, arrived with their other children, reuniting the family. Israel was a charter member of the Orthodox community, and Jenny maintained a kosher home. Their influence on the entire Jewish community, Orthodox and Reform, was profound. (Courtesy of Regina Lotven.)

Isadore (left) and Jake Lorven (right) were two of Israel and Jenny's sons, shown here in the early 21st century. They belonged first to the Orthodox community and then the Reform one. Isadore tutored the bar and bat mitzvah children when no rabbi was available. Jake offered financial support to both the Jewish and the larger community. Education was his cause, and he sent Jewish children on trips to Israel and supplied educational scholarships to those in need. (Courtesy of the Telling Traditions Project.)

Synagogue documents show that Jacob Karchmer (pictured), cousin to Samuel Yoffie, was also a founder of the Orthodox Community in Springfield. After serving in World War I, he went into business with his brother Nathan, opening a salvage and auto-supply business. He served in World War II for a short time as well before returning to Springfield and working in the pipe and iron business with his father. (Courtesy of Special Collections and Archives, Missouri State University.)

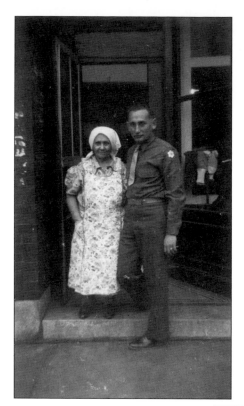

Hyman Lotven was the treasurer of Sha'are Zedek, warden of the cemetery, and a player on the synagogue bowling and baseball teams. During World War II, he served as a translator for the military, as he could speak Yiddish. A shoe salesman, he and his wife, Regina, often had Jewish graduate students from the local colleges staying at their home. Here he is photographed while home on furlough in 1942 with his mother Jenny Lotven. (Courtesy of Gytel Lotven.)

David Ellman, despite living in Springfield for less than a decade, was one of the charter members of Sha'are Zedek. He was in business for a time with his brother Benjamin but, upon his own divorce, returned to St. Louis to be with his extended family. He went on to become a wealthy businessman. (Courtesy of Marlita Wennerman Weiss.)

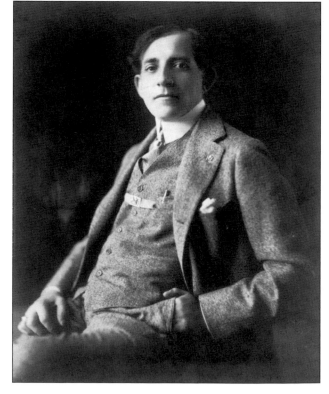

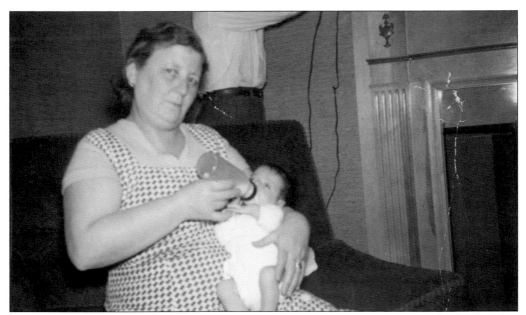

Rosa Tuchmaier arrived in 1950 with her younger daughter, Gytel, and son Henri to be with her older daughter, Regina Tuchmaier Lotven. After World War II, this was really all the family she had left. She eventually lived with Gytel and her husband, Isadore Lotven. She is photographed feeding her granddaughter Simone Lotven. (Courtesy of Gytel Lotven.)

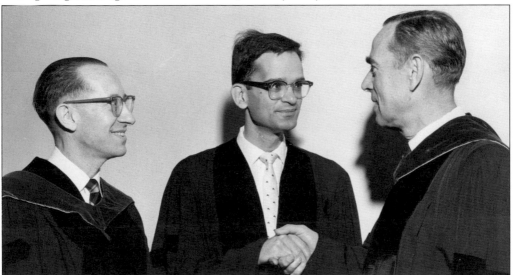

Walter Jacob (center) arrived in Springfield as a *Kristallnacht* refugee when his father was hired as the community rabbi. He graduated from Drury University and received his rabbinic ordination at Hebrew Union College (HUC) in Cincinnati, Ohio, becoming a 17th-generation rabbi. During his studies, he would return to Springfield and lead the Reform congregation during the High Holy Days while his father led the Orthodox. In 1961, he received his doctorate of divinity. In this photograph, Walter is seen with Prof. Matitiahu Tsevat (left) and Nelson Glueck, president of HUC (right). In 1999, Walter helped found the Abraham Geiger Kolleg, the first Reform seminary to operate in Germany since the Holocaust. (Courtesy of the Jacob Rader Marcus Center of the American Jewish Archives, Cincinnati, Ohio, americanjewisharchives.org.)

Stuart Federow (right) went to the Reform congregation's religious school, though his family attended the Orthodox congregation. (The Orthodox community did not have a religious school.) During his childhood, he realized he wished to be a rabbi. After leading congregations around the country, he spent the years between 1989 and 1995 leading the B'nai Brith Hillel Foundation of Greater Houston. During this time, he counseled Ilan Ramon, the Israeli astronaut who would later die in the *Columbia* disaster. (Courtesy of the Jacob Rader Marcus Center of the American Jewish Archives, Cincinnati, Ohio, americanjewisharchives.org.)

Raised in Ava, Missouri, Shayna Peavey DeLowe and her mother, Judith Peavey, would drive once a month to Springfield for Sunday school. They later moved into Springfield and attended the synagogue regularly. Shayna graduated from the University of Missouri–Columbia with a music degree and then attended Hebrew Union College in New York City. She was ordained a cantor in 2007. (Courtesy of Shayna Peavey DeLowe.)

Four

JEWISH LEADERS IN THE SPRINGFIELD COMMUNITY

Springfield's Come Back to God parade, which was held on May 1, 1953, began at the Shrine Mosque downtown. Pictured from left to right, Fr. William Bresnahan of St. Joseph's Catholic Church, Rabbi Ernest Jacob of Temple Israel, and Rev. Vincent Grey of Woodland Heights Presbyterian Church (and president of the ministerial alliance) led the parade. Over the rabbi's left shoulder can be seen Bob Deutsch, carrying the Israeli flag. The 51-car parade, with a few marching units and no marching bands, was intended to highlight the importance of God and peace in the community. (Courtesy of the History Museum for Springfield–Greene County.)

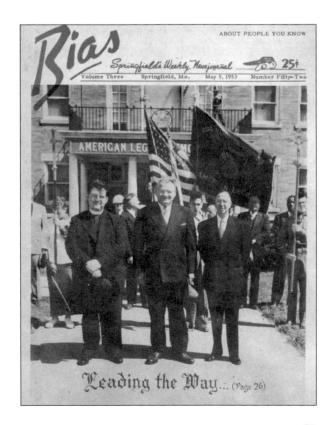

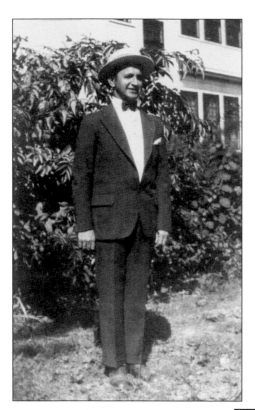

Benjamin Moskowitz was on the board of the Shrine Mosque during its building and also ran the National Auto Supply store. He would occasionally take one of his five daughters with him to the Orthodox synagogue, where they would sit on the back bench and wait for him to finish praying. (Courtesy of Mary Moskowitz Watters and Jim Watters.)

Samson Wennerman (left) grew up in Springfield and attended Drury University and then Washington University Medical School in St. Louis. He and his brother Jacob (right) had a business selling costumes, which helped Samson pay for school. During World War I, he served in the Medical Corps as a surgeon. (Courtesy of Marlita Wennerman Weiss.)

Fannie Arbeitman (above), along with her friend Mildred Wheeler, founded the public kindergartens in Springfield. Starting in 1935, they petitioned the school board for permission. It was finally granted, and they were given a basement room in Rountree School, where kindergarten continued into the 21st century. She was a teacher at the synagogue's religious school as well. (Courtesy of the *Springfield News-Leader*.)

David LeBolt (left) was very active in the community; this 1948 photograph shows him being inducted as president of the Rotary Club, an organization he was long associated with. He also was busy with the Boy Scouts, Red Cross, Elks Club, and Retail Merchants Association, and was on the board of directors for the chamber of commerce and the board of governors of Temple Israel. (Courtesy of Doug and Denise LeBolt.)

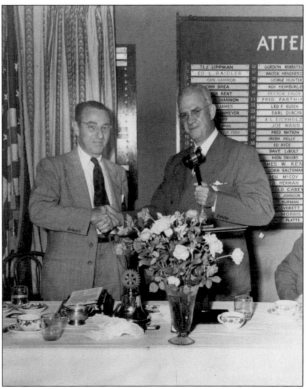

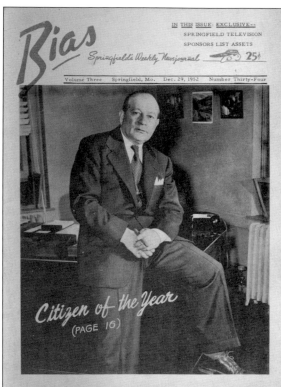

Nathan "Bill" Karchmer (son of Ben Karchmer, a charter member of the Orthodox congregation) was the first and only Jewish mayor of Springfield, Missouri, in 1951. His father ran the Karchmer Metal & Iron Co., which later became Karchmer Pipe & Supply Co. During his tenure, the office of city manager was created to divide the duties of mayor between a hired employee and an elected official. (Courtesy of the History Museum for Springfield–Greene County.)

Nadine Smith (right), Fannie Arbeitman's daughter, was the second Jewish public school teacher in Springfield. One of her fond memories of being a teacher was the opportunity to decorate a Christmas tree in her classroom, something she had never done at home. She also taught at the synagogue religious school from the time she was 15 until she graduated from college. (Courtesy of the Telling Traditions Project.)

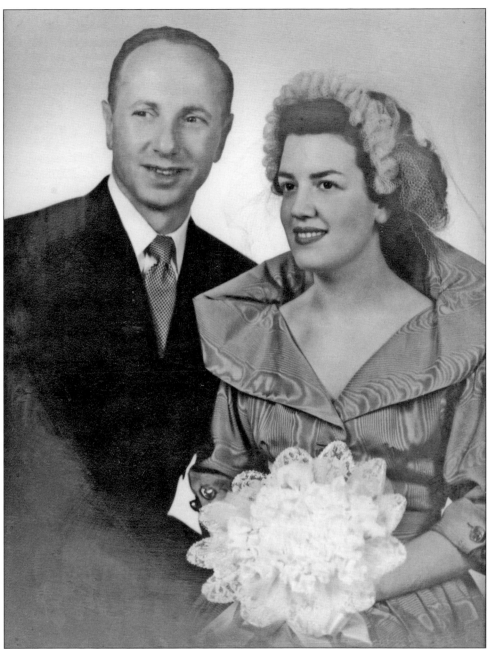

Isadore Lotven was born in Russia in 1908 and arrived in Springfield in 1921, when he and his brothers and mother were reunited with his father and sister. As a son of one of the founders of the Orthodox community, he, too, became a leader of the Jewish community by tutoring children to become *b'nei mitzvah*. Buying shoes from Isadore Lotven was listed in the *Springfield News-Leader* as one of the top 10 criteria for being a Springfieldian. Gytel Tuchmaier was born in France in 1925 and fled the Nazi occupation. In 1950, Gytel followed her sister Regina Tuchmaier Lotven to Springfield, where she met her brother-in-law Hyman's brother Isadore. They were married shortly thereafter. Gytel is a mainstay of the Jewish community, still baking the traditional braided Sabbath bread, challah, for every weekly service. (Courtesy of Tony and Melynda Lotven.)

Harold "Hal" Lurie was born and raised in Springfield by Lithuanian immigrants. He received his doctor of medicine degree from the University of Missouri–Columbia (MU). After military service, he returned to Springfield to practice. As one of the Singing Doctors of Springfield, he helped raise scholarship money for medical students at MU. Because of this work, he was the first recipient of the Mizzou Alumni Legacy Award. (Courtesy of the Telling Traditions Project.)

Norwin Yoffie (back right) was president of his 1941 high school class. Later, he graduated from University of Missouri with a degree in journalism and served in World War II. He founded the Freedom of Information Coalition and was first president of the San Rafael Education Foundation. (Courtesy of Central High School.)

Sandy Asher has written over 25 books for children, as well as numerous plays. Sandy earned the prestigious National Jewish Book Award and cofounded the Web site *America Writes for Kids*. From 1986 until the early 21st century, she was the writer in residence at Drury University. (Courtesy of Drury University Archives.)

Rabbi Rita Sherwin (center, with the challah) blesses the Sabbath bread at the social hour after the service honoring her decade of service to Temple Israel. An honorary member of the Council of Churches of the Ozarks, Rabbi Sherwin worked hard for minority inclusion. One of her first acts upon arriving in Springfield in 1996 was to make sure that non-Christian children would not be penalized for missing school on their holy days. (Courtesy of the Telling Traditions Project.)

Marla Marantz is a local activist who belongs to such groups as Citizens for a United Springfield and Progressives of Southwest Missouri and received the Nelson and Betty Parnell Humanitarian Award in 2012. She was a teacher before she retired, spent a number of years as the office manager for the synagogue, and also taught in the religious school. (Courtesy of the Telling Traditions Project.)

Five

COMMUNITY SERVICE

The Temple Israel Community Garden, founded by Joel Waxman, was intended as a way to use the synagogue property in support of the community. With master gardener (and fellow congregant) Harry Dorman, Waxman opened the 4,000-square-foot garden in 2005 and, with the help of other congregants, has donated upwards of 1,800 pounds of food annually for over three years to the Ozarks Food Harvest, the local food bank. Eggplant, potatoes, winter squash, okra, yard-long beans, and sweet potatoes are grown. In 2009, they won the Fain Award from the Union of American Hebrew Congregations. Here, Judith (Winston) Peavey (left) and Sue (Winston) Conine (right), commonly referred to as the "Tater Sisters" because of their work in the garden, are planting. (Courtesy of Joel Waxman.)

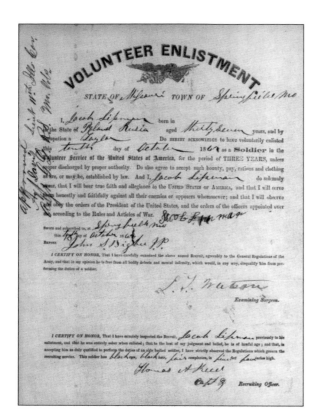

Jacob Lippman is the earliest recorded Jew in the area, having moved into Willard, Missouri, in 1860. He enlisted in the 24th Regiment in the Union army in 1862, only to be discharged a year later with a disability. He never saw active duty. He was listed in the 1870 Greene County census, and the 1880 census has him documented as a resident of Springfield.

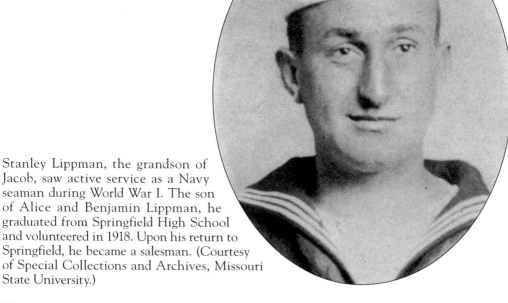

Stanley Lippman, the grandson of Jacob, saw active service as a Navy seaman during World War I. The son of Alice and Benjamin Lippman, he graduated from Springfield High School and volunteered in 1918. Upon his return to Springfield, he became a salesman. (Courtesy of Special Collections and Archives, Missouri State University.)

In 1966, Walter Sidney Rosenbaum volunteered with the US Air Force and served as a medic. He did so to earn money to attend college and, upon completion of his service, enrolled in Missouri State University. (Courtesy of Sid Rosenbaum.)

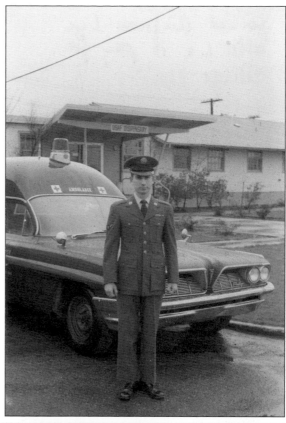

The Jewish community has always focused on education, both for themselves and for others. At the podium, Arthur Rosen, who became a spokesman for the Jews, talks to various groups about Judaism. Here, he speaks about escaping Nazi Germany at a public Holocaust panel. Seated behind him are two women, Gytel Lotven (left) and Regina Lotven (right), who are present to speak about their experiences fleeing occupied France. (Courtesy of the *Springfield News-Leader*.)

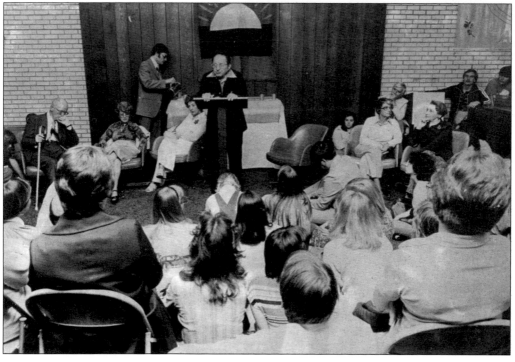

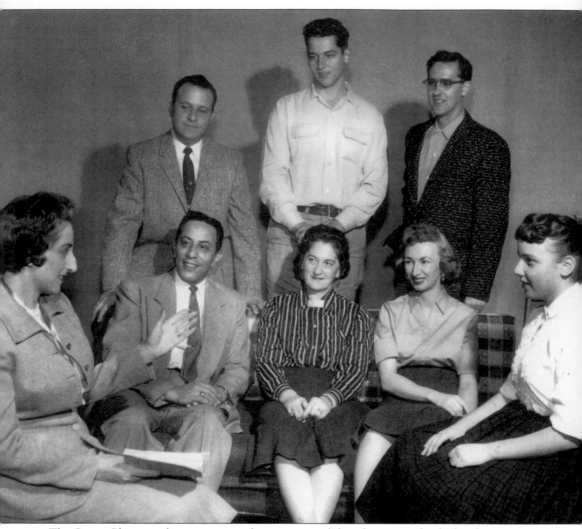

The Center Players, a theater group at the synagogue, did performances for the local community. In this image are, from left to right, (first row, seated) Sylvia Goldberg (director), Saul Goldberg, Lena Rosen, Betty Arbeitman, and Ronni Bisman; (second row, standing) Bob Bisman, David Kenton, and Ben S. Arbeitman. (Courtesy of Special Collections and Archives, Missouri State University.)

Gytel Tuchmaier Lotven came to Springfield at the behest of her sister and brother-in-law, leaving a government job in France. She is extremely active in the Sisterhood and the congregation, as well as the Franklin D. Roosevelt Women's Democratic Club in Springfield and the Yiddish Book Center in Massachusetts. She is most famous for her cooking and baking skills, which, over the last 60 years, have raised thousands of dollars for the synagogue. (Courtesy of the *Springfield-News Leader*.)

To celebrate its 100th anniversary and to raise some money for the congregation, the Sisterhood gathered favorite recipes from members of the congregation and presented them in a format to help simplify cooking for each holiday. Thus, one can cook a meal as prepared by favorite members. (Courtesy of Temple Israel.)

Centennial Celebration Cookbook

100 years of Jewish Cooking in the Ozarks

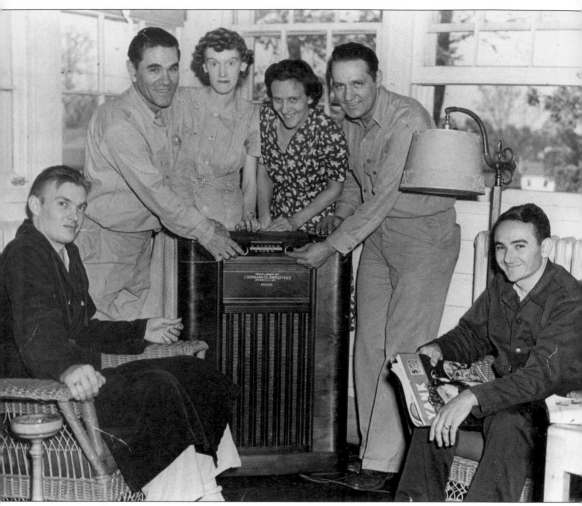

At its peak, the Springfield D.M. Oberman Manufacturing Company employed 1,150 workers. Apparently, the company encouraged community involvement, as this group of employees is presenting the radio it had raised money to purchase to soldiers recuperating at O'Reilly Hospital. The factory closed in 1949. (Courtesy of the History Museum for Springfield–Greene County.)

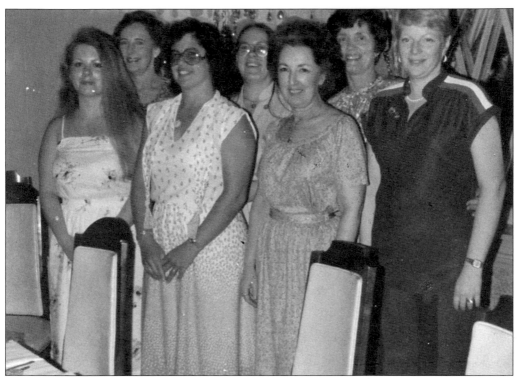

Hadassah, a women's Zionist group, was founded in 1909 by Henrietta Szold. The members' purpose is to provide aid to communities in Israel. They were one of the five largest aid contributors during World War II. Springfield had a chapter; the 1980 incoming board is seen in this photograph. (Courtesy of Dianna Long.)

B'nai Brith is an international organization founded in 1843 by 12 German Jewish immigrants in New York City. The organization's mission is to aid Jews around the world. Springfield hosted the Benjamin Solomon Lodge, whose members in 1976 were, from left to right, (first row) Jake Lotven, Isadore Lotven, Hyman Lotven, and Rabbi David Wucher; (second row) Ben Arbeitman, Larry Rosenbaum, Bill Arbeitman, and Leo Forbestein. (Courtesy of Sid Rosenbaum.)

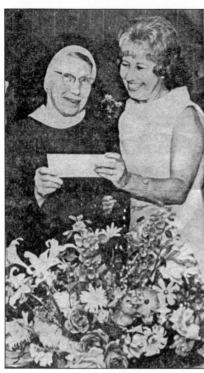

Fannie Arbeitman (right) volunteered at St. John's (now Mercy) Hospital for over 50 years. She even helped it move in 1952 by loading her car with materials. Aside from winning numerous awards for her service to the hospital, she was the first woman on the hospital's advisory board and was also involved in numerous other charities. Arbeitman is seen in this image giving Sister Mary Dominic a gift at the sister's retirement. (Courtesy of Nadine Arbeitman Smith.)

Evan Van Ostran (first row, far right) is seen at his policy academy graduation at Drury University in 2008. The Springfield Police Department was founded in 1858; however, Evan is evidently only the second Jewish officer (the first being Kevin Swekard, who joined the force in 1997). (Courtesy of Mandy and Ray Van Ostran.)

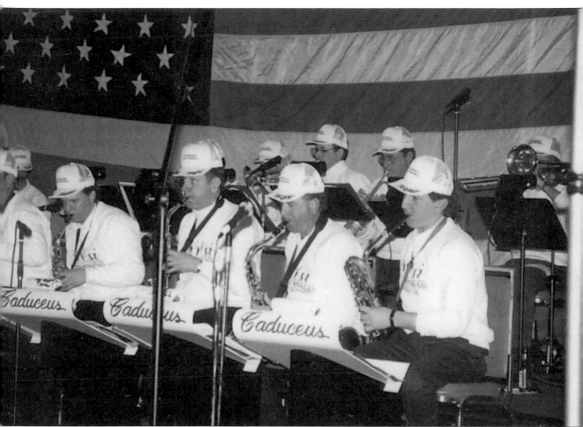

Joel Waxman (far right) was a founding member of Caduceus, a band composed of doctors that performs at many goodwill events. Here, it plays at the University Plaza Hotel in tribute to military personnel who participated in Desert Storm. Troops that day had returned to Fort Leonard Wood, two hours away, and opted to immediately take a bus to Springfield to honor the band that was honoring them. (Courtesy of Steve Bowman Jr.)

Walter Sidney "Sid" Rosenbaum and Lother "Larry" Rosenbaum have belonged to the Masons for decades. They are two of many local Jews who have contributed to the charity work that the Masons of Springfield pride themselves on. (Courtesy of Sid Rosenbaum.)

On February 6, 2001, the Jewish cemetery was desecrated with swastikas and other Nazi symbols. The Council of Churches of the Ozarks paid for the cleaning, and the rededication ceremony was attended by both Jews and Christians on February 11. (Courtesy of the *Springfield News-Leader*.)

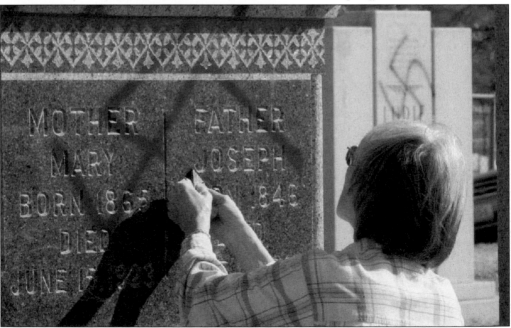

Six

EDUCATION

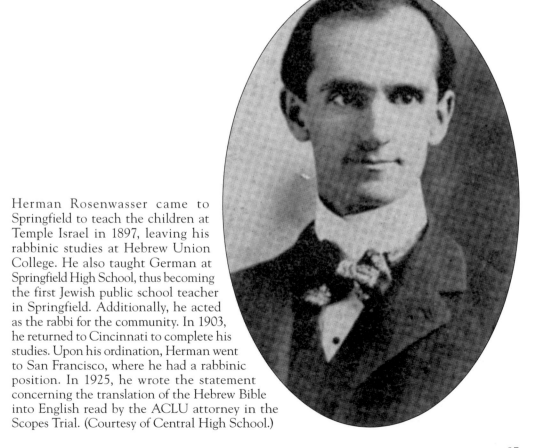

Herman Rosenwasser came to Springfield to teach the children at Temple Israel in 1897, leaving his rabbinic studies at Hebrew Union College. He also taught German at Springfield High School, thus becoming the first Jewish public school teacher in Springfield. Additionally, he acted as the rabbi for the community. In 1903, he returned to Cincinnati to complete his studies. Upon his ordination, Herman went to San Francisco, where he had a rabbinic position. In 1925, he wrote the statement concerning the translation of the Hebrew Bible into English read by the ACLU attorney in the Scopes Trial. (Courtesy of Central High School.)

Arthur Marx (back right) gave the opening address at the 1911 commencement ceremonies for Springfield High School. He was the son of an influential businessman and later inherited the family business. This picture also shows Byron Florea, Loucie Sperry, and Marjorie Finney. (Courtesy of Central High School.)

Frederick Lippman, the son of one of the first Jews in the area, was a member of the Obelisk fraternity at Drury College (now Drury University), which he attended between 1917 and 1921. The fraternity was founded in 1911 and, in 1919, became the Drury College chapter of Sigma Nu. (Courtesy of Drury University.)

Zelda Ellman, whose father, Benjamin, and uncle David Ellman were charter members of Sha'are Zedek, also participated fully in her community. In high school, she was a member of the Girl Reserves (a junior YMCA), Athenian Literary Society, and Girls' Glee Club. (Courtesy of Marlita Wennerman Weiss.)

Arthur Marx belonged to Phi Alpha Sigma in 1914 while at Drury College (now Drury University). Phi Alpha Sigma, founded in 1910, became Theta Kappa Nu and is now the Theta-Sigma chapter of Lambda Chi Alpha, one of the largest fraternities in the country. (Courtesy of Drury University.)

Bessie Yoffie, daughter of Max and Lizzie Yoffie, is in this 1921 photograph of the Girl Reserves at Springfield High School (now Central High School). The Girl Reserves was a junior branch of the YWCA, which promoted service to the community. (Courtesy of Central High School.)

Jacob Lotven, son of a charter member of the Orthodox community, was an immigrant to the United States. He was the only child in his family to complete high school. In his senior year, 1929, he won first place in an oratory competition; he later became an attorney in Washington, DC. (Courtesy of Central High School.)

Hyman Lotven, an immigrant to the United States, did not have the opportunity to graduate from high school. He did, however, participate in all that he could before dropping out to help support his family. He is visible in this 1933 photograph of the Fairbanks Debating Club. (Courtesy of Central High School.)

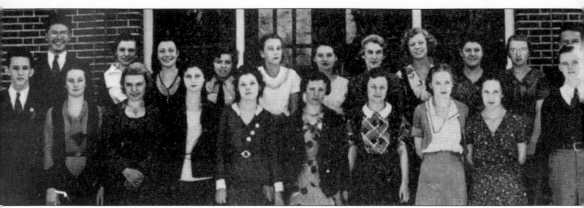

Bessie Arbeitman, daughter of William and Rose Arbeitman, was involved in the newly founded art club in high school. William Arbeitman was a charter member of Sha'are Zedek and ran various businesses in the city until his death in 1933, the year this photograph was taken. (Courtesy of Central High School.)

Eleanor Tarrasch was a member of Central High School's Latin Club and willingly participated in a special program on Roman beauty secrets for women's hair and faces. Chuck Webb is acting as the beautician, and David Laurence gave a scholarly lecture on the subject. (Courtesy of the History Museum for Springfield–Greene County.)

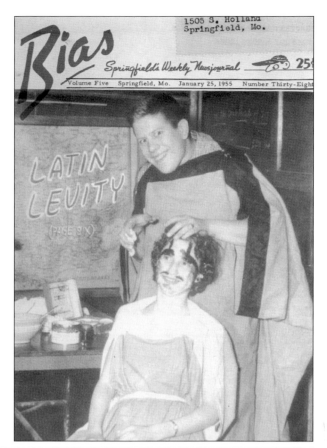

The Greenwood Laboratory School had its own newspaper for many years. In 1944, Jeanne Rose Strauss (whose father, Lester, was instrumental in organizing Sha'are Zedek) was on the staff. The paper recently ceased to exist. (Courtesy of Missouri State University's Greenwood Laboratory School yearbook.)

The 1947 Greenwood Laboratory School's Jays basketball team won a championship, which Jack Bluestein had a hand in. The family had only recently moved to Springfield during the mid-1940s, when Jack's father opened an appliance store. (Courtesy of Missouri State University's Greenwood Laboratory School yearbook.)

Jack Bluestein (second from right in front row) was also on the football team of Greenwood Laboratory School in 1948. That year was not an easy one for the team, but Jack, a senior, did earn his letter. (Courtesy of Missouri State University's Greenwood Laboratory School yearbook.)

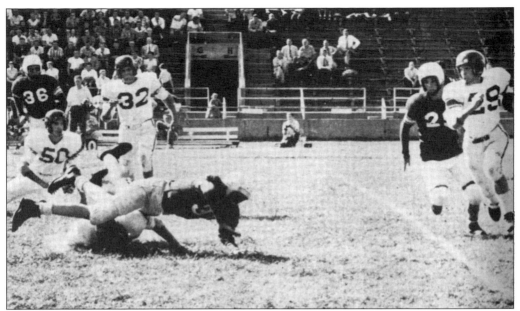

Mark Rosen was cocaptain of the Greenwood Laboratory School football team, the Jays, in 1957. The team did not have a winning year, but it played valiantly. Here, Mark is seen blocking for Charles Ryer (No. 20) of Greenwood. (Courtesy of Missouri State University's Greenwood Laboratory School yearbook.)

From left to right, Ben Lipman, Rose Lipman, David Lipman, Lorraine Lipman Raskin, Deborah Raskin, and Bob Raskin attend David's 1953 graduation from the University of Missouri—Columbia. David studied journalism and began his career as the editor of Springfield High School's newspaper, eventually joining the St. Louis Post Dispatch, where he worked for 36 years (including 14 as the managing editor, a goal he had set in the eighth grade). He is well known for his seven books on various sports figures. (Courtesy of Lorraine Lipman Raskin.)

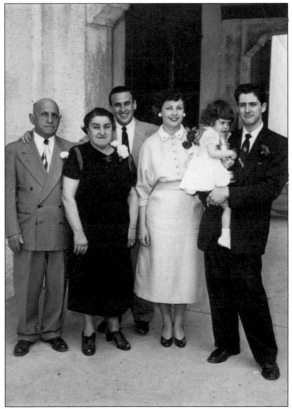

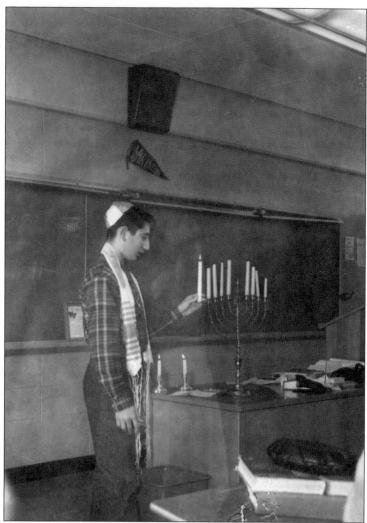

Jewish children like Walter Sidney Rosenbaum often teach their classmates about Jewish traditions. Here Sid introduces his Parkview High School classmates to Shabbat (Sabbath) and Hanukah during the 1959–1960 school year. These opportunities provide a chance to foster conversation about differences and to allay fears that can be brought about by ignorance. (Courtesy of Sid Rosenbaum.)

Regina Lotven (first row, sixth from left), arrived in the United States as a war-refugee bride, speaking no English and not having completed school in France because of the war. She graduated from Missouri State University in 1959. In this 1958 photograph, she sits with fellow members of Pi Beta Chi, the honorary science fraternity. (Courtesy of Missouri State University's *Ozarko Yearbook*, Special Collections and Archives, Missouri State University.)

Max Cohen (son of Louis and grandson of Max, both charter members of Sha'are Zedek) was very involved in his high school. Not only was he a member of the science club and the newspaper, he was also class president. (Courtesy of Central High School.)

Religious school was a very important part of the Jewish community. This 1950 class photograph shows, from left to right, (first row) Francie Rosen, Tony Tarrasch, Eleanor Tarrasch, and unidentified; (second row) David Cary Karchmer, ? Wallerstein, Bob Deutsch, Nick Weinsaft, and Phyllis Goldberg; (third row) Alan Arbeitman, Mark Rosen, ? Pollock, and ? Farbstein; (fourth row) Rabbi Ernest Jacob, Lois Weinsaft, and Arthur Rosen, (Courtesy of the History Museum for Springfield–Greene County.)

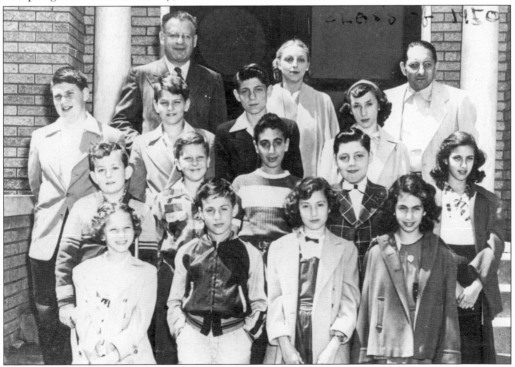

Temple Israel prides itself on having a preschool religious educational experience. Here, Jacob Gill and Rachel Tarrasch are learning about the Sabbath as they pour grape juice into glasses in preparation for the blessing over the wine. (Courtesy of the *Springfield News-Leader*, photograph by Jerry Henkel.)

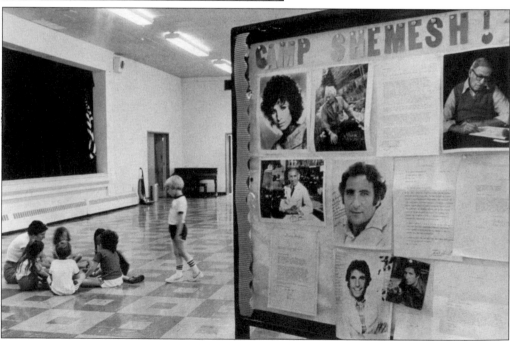

In parallel to the Christian religious schools in the area, the Jewish community sponsored summer programs for their children. At the synagogue on Belmont Road, Linda Leavitt (far left) leads children in a game during Jewish summer camp in June 1981. In the foreground is a bulletin board of famous American Jews. (Courtesy of the *Springfield News-Leader*, photograph by Jerry Henkel.)

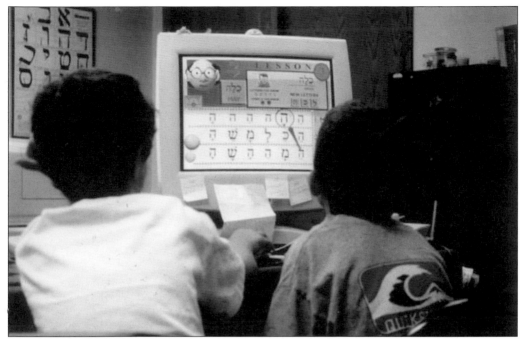

The religious school has adapted to modernity, striving to offer the best education possible. Here, students study Hebrew on the computer. Hebrew school is twice a week and is separate from the religious school, which focuses on theology, history, and practice. Hebrew school is about learning the language so that the prayers can be properly recited and understood. (Courtesy of the Telling Traditions Project.)

The Faculty Senate (photographed in 1988) at Southwest Missouri State University, now Missouri State University, is the faculty's representation in the shared-government policy on campus. Stefan Broidy (far right), in addition to being faculty in the College of Education, sat on the Faculty Senate for many years. (Courtesy of Missouri State University's *Ozarko Yearbook*, Special Collections and Archives, Missouri State University.)

Marc Cooper (second row at far left), hired in 1980, was the first Jewish faculty member to receive tenure at Missouri State University in 1984. He teaches in the History Department, specializing in ancient Near Eastern history. Additionally, he was department head twice between 1997 and 2004. After his arrival, other Jewish faculty members were hired. (Courtesy of Missouri State University's *Ozarko Yearbook*, Special Collections and Archives, Missouri State University.)

Rabbi David Wucher (third row at far left) is pictured here with the Religious Studies Department at Missouri State University. He taught in both the Languages and Religious Studies Departments while also serving as rabbi for the Jewish community. (Courtesy of Missouri State University's *Ozarko Yearbook*, Special Collections and Archives, Missouri State University.)

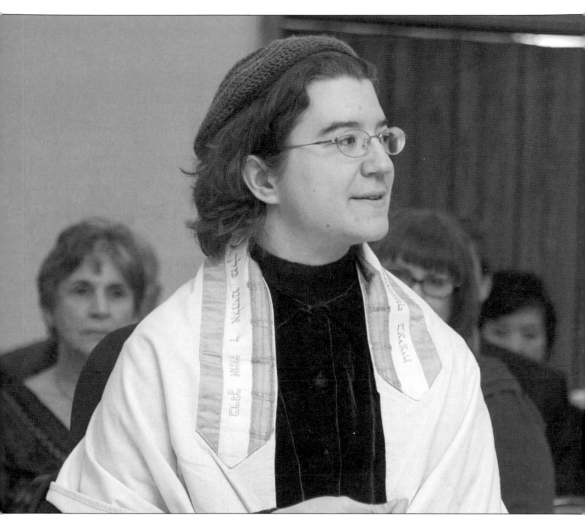

Rabbi Julia Watts Belser, PhD, was hired in 2010 as the first professor of Jewish studies in the Religious Studies Department at Missouri State University. Before this, the local rabbi was hired on a part-time basis to teach the Introduction to Judaism course. Julia is a specialist in Talmud and Jewish ecology and ethics. (Courtesy of Mara W. Cohen Ioannides and Robert E. Anderson III, photograph by Melissa Ford Photography.)

Regina Lotven (left) spends time studying and chatting with, from left to right, Marion Arel Spicer, Ahmad Dodger, and Richard Foster. Even though Regina was a nontraditional student, starting much later than the typical age of 18, she was very much involved with her fellow students. Even after she graduated, she continued to have the French Club to her house for regular salons so that they could practice French with her, a native speaker. (Courtesy of Missouri State University's *Ozarko Yearbook*, Special Collections and Archives, Missouri State University.)

Seven

SOCIAL ACTIVITIES AND THE ARTS

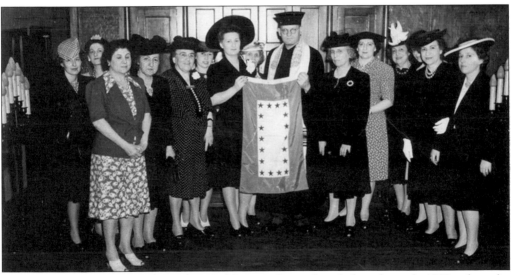

The Sisterhood grew from the Ladies Aid Society. It was founded in the early 1930s when the women of both the Orthodox and Reform communities joined together to support the Jewish and Springfield communities. Its original purpose was to raise money for the religious school and other charities in the larger community and to provide a way for the women to gather socially outside religious services. During World War II, the group organized Sabbath dinners for the soldiers at O'Reilly Hospital. Today, the Sisterhood continues charity work; its biggest projects are bake sales featuring Jewish goods, which are held at the annual synagogue Arts Fest and at other times to benefit both the Jewish and larger communities. The group also frequently provides the dessert for the socials during the High Holy Days. It continues the tradition of social events like luncheons and outings around the area and is returning to some old classics like mah-jongg and card parties. (Courtesy of the History Museum for Springfield–Greene County.)

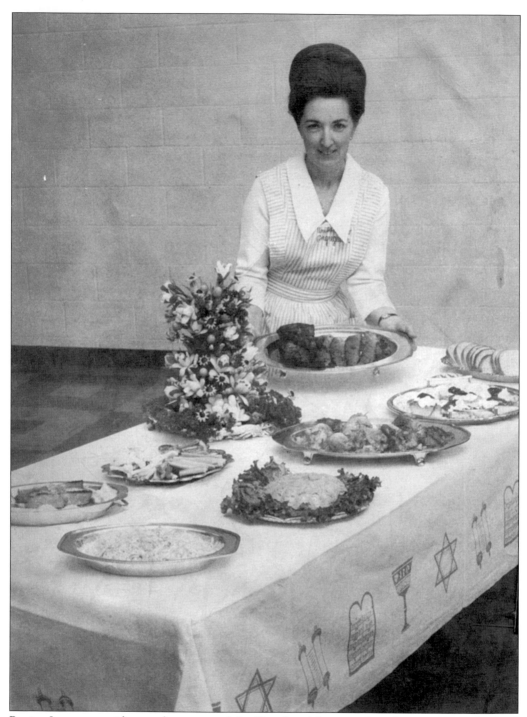

Regina Lotven, president and treasurer of the Sisterhood for a number of years, is an influential member of the Jewish community. Regularly preparing Jewish treats for all the holidays, Regina has also contributed home-crocheted afghans for raffles. (Courtesy of the *Springfield News-Leader*.)

In 1965, the Sisterhood began the Gourmet Dinners to raise money for the organization as well as for the Sunday school. It annually collected between $5,000 and $6,000. The menu featured Jewish delicacies not found in local restaurants, and specific recipes were selected by group tasting sessions. The dinners were so popular in Springfield that the Sisterhood had to offer two sessions. Finally, it had to cap the event at 300 people. (Courtesy of Special Collections, Missouri State University.)

In this 1911 production of *The Hero of the Gridiron*, staged at Springfield High School, Stanley Lippman portrayed Mr. Randolph. Stanley, the grandson of the first Jew in the area, Jacob Lippman, was in many theater productions at the high school and grew up to became a salesman. (Courtesy of Central High School.)

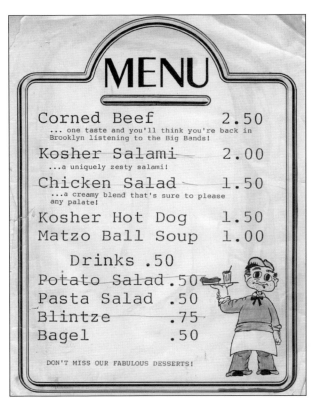

David LeBolt was the yell leader of the High Y Club at Springfield High School in 1917 and 1918. Both he and Lawrence Lippman are in this photograph. The High Y Club is the high school organization associated with the Young Men's Christian Association (YMCA). There was no discrimination in Springfield about Jews belonging to the YMCA. (Courtesy of Central High School.)

Mildred LeBolt, daughter of Abraham and Della LeBolt, participated in the May Day celebrations while she attended Springfield High School. She was one of many local Jews who participated in the arts. (Courtesy of Doug and Denise LeBolt.)

Emmanuel Marx was a member of the Drury Oratorical Association (DOA) in 1906. The DOA was founded in 1883 as a literary society for college men. The focus was on debate, but poetic recitation and musical composition were also encouraged. (Courtesy of Drury University.)

In 1910, both Stanley Lippman, whose grandfather was one of the first Jews in the county, and Sam Wennerman, whose father was a charter member of Sha'are Zedek, participated in the boys' Oratorical Association at Springfield High School. (Courtesy of Central High School.)

In 1910, Springfield High School presented a comic opera, *The Captain of Plymouth*. Zeda Lippman, daughter of grocery-owners Fred and Olive Lippman and granddaughter of Jacob Lippman, performed as one of the Indian women. (Courtesy of Central High School.)

Herschel Karchmer, the grandson of one of the founders of the Orthodox community in Springfield, played on the 1934 Missouri State University training school football team. He is in the front row, second from the right. (Courtesy of Missouri State University's *Ozarko Yearbook*, Special Collections and Archives, Missouri State University.)

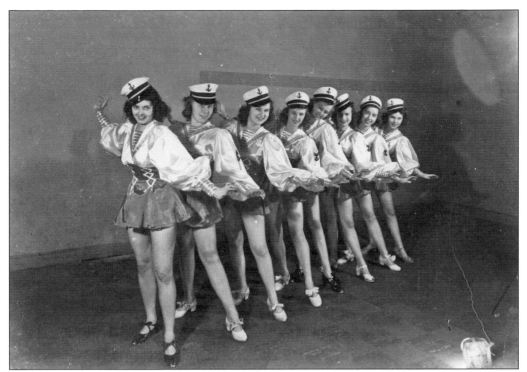

Third from left is Betty Jean Tillman, who grew up in Ava, Missouri, and attended dance classes in Springfield. She married Benjamin Arbeitman, with whom she had two daughters. (Courtesy of the History Museum for Springfield–Greene County.)

Harold Arbeitman, son of William Arbeitman (one of the founders of the Orthodox community), played percussion in the Missouri Teachers College band in 1939 and 1940. (Courtesy of Missouri State University's *Ozarko Yearbook*, Special Collections and Archives, Missouri State University.)

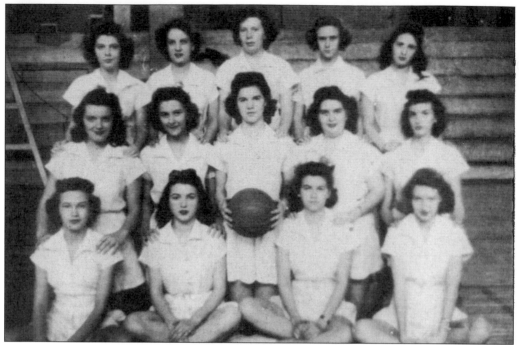

The purpose of the Greenwood Girls Athletic Association was to promote good health, clean living, and sportsmanship. It offered extracurricular activities such as hockey, archery, tennis, and hiking. Jean Rubenstein (third row at far right) and Jean Rose Strauss (third row, second from right) were both participants. (Courtesy of Missouri State University's Greenwood Laboratory School yearbook.)

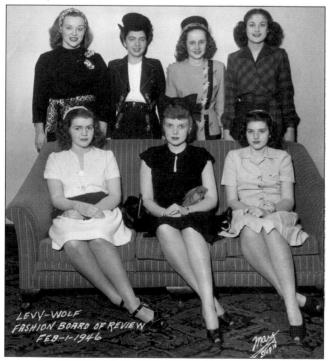

The Levy-Wolf department store, owned by the LeBolt family, began a Fashion Board of Review that helped it select the most fashionable clothing and accessories for the modern young woman. It was filled with female high school and college students, including Lorraine Lipman (second row at far right). Lorraine was on the Fashion Board of Review for a number of years and later used this experience in her career as a journalist. (Courtesy of Lorraine Lipman Raskin.)

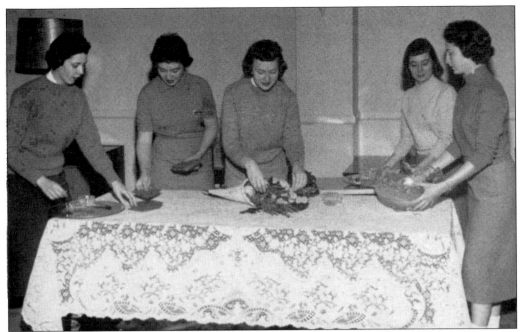

The recreation committee at Missouri State University discusses plans for a reception in 1958. Eleanor Tarrasch (far right) learned her hostess skills from her mother, Ena, who was considered one of the most elegant women in Springfield. (Courtesy of Missouri State University's *Ozarko Yearbook*, Special Collections and Archives, Missouri State University.)

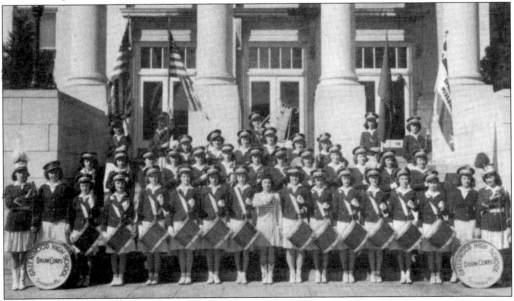

The Greenwood Laboratory School Drum Corps on the Missouri State University campus was founded in 1937 by Mrs. Bugg. The band rehearsed Monday, Wednesday, and Thursday mornings before school and played for football and basketball games. Two members of the Jewish community were in the 1944 Drum Corps: Jean Rose Strauss (first row, 11th from left) and Jean Rubenstein (second row, second from right). (Courtesy of Missouri State University's Greenwood Laboratory School yearbook.)

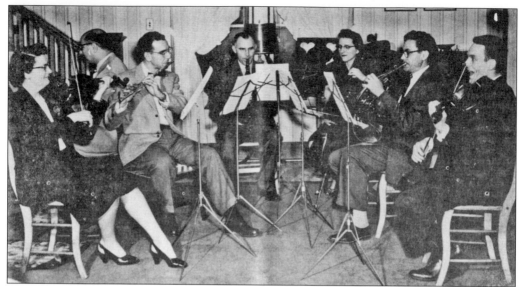

Ernest Tarrasch was not only a well-respected physician, he was also well known for his talent at the keyboard. Here he is, second from left, participating in the Springfield Chamber Music Society along with, from left to right, Cordelia Baldwin (left of Tarrasch), Hambarson Bogosian (right of Tarrasch), Walter Scharpf, Marjorie DeLange Kopp, Dr. Dustman, and Fred Thede. (Courtesy of the History Museum for Springfield–Greene County.)

The 1956 Delta Sigma Alumnae Advisory Board is, from left to right, Rose Largo, faculty advisor; Betty Marx Arbeitman; Doris Bush; Maxine Sullivan; and Darlene Norton Rubenstein. Betty and Darlene were also very involved in the Jewish community, which their husbands' families had helped to found. (Courtesy of Missouri State University's *Ozarko Yearbook*, Special Collections and Archives, Missouri State University.)

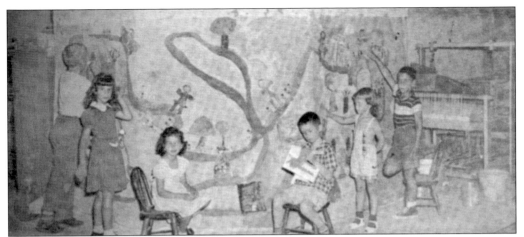

The Springfield Art Museum regularly holds art classes for the community. Among the children working on this mural in 1951 are Janet Rosen (second from left) and her brother David Rosen (far right). (Courtesy of the History Museum for Springfield–Greene County.)

Francie Rosen, fifth from left in the first row, sang with the Greenwood Spinners during her years at Greenwood Laboratory School. The Greenwood Spinners, founded in 1956 by Byron McCurry, were known for their voices and formal attire. (Courtesy of Missouri State University's Greenwood Laboratory School yearbook.)

Mark Rosen (second row, far left), seen here with the Greenwood Laboratory Orchestra, grew up to inherit the Busy Bee Department Store from his father. (Courtesy of Missouri State University's Greenwood Laboratory School yearbook.)

In 1974, Sid Rosenbaum (second row, second from right) was treasurer of the Rifle and Pistol Club at Missouri State University. Organized in 1955, the club is associated with the Bear Battalion of the ROTC. Sid brought his military experience to the club, having served in the military during the 1960s. (Courtesy of Missouri State University's *Ozarko Yearbook*, Special Collections and Archives, Missouri State University.)

The Tae Kwon Do Club at Missouri State University was founded in the early 1970s. Among its members was Ginger Terrasch, seated third from the left in the front row. Ena Terrasch, who escaped Germany just before World War II, was inspired by her experience as an orphaned refugee to adopt two Vietnamese girls, Ginger being one, to make sure they never felt alone. (Courtesy of Missouri State University's *Ozarko Yearbook*, Special Collections and Archives, Missouri State University.)

Peggy Kaplan, widow of Rabbi Sol Kaplan, is an artist seen here in 1980. Her works include puppets, paintings, and batiks (some of which hang in the social hall at Temple Israel). She currently resides in Memphis, Tennessee. (Courtesy of the *Springfield News-Leader*.)

Rabbi Solomon Kaplan liked to use this puppet of himself, designed by his wife, when he was doing lessons with children. He was director of the Southwest Region of the Union of American Hebrew Congregations (now the Union for Reform Judaism) before arriving in Springfield, where he served the congregation until his death in 1982. (Courtesy of the Telling Traditions Project.)

Joel Waxman (upper right), who was deeply involved in service to the community, is seen here with Caduceus, a band of doctors. Joel helped found this band, which performs for many events in the area and provides a way for participating doctors to relax through their music. (Courtesy of Steve Benton Jr.)

Dorothy Moskowitz, whose grandfather was a charter member of the Orthodox congregation, was the drum major for the Kilties at Springfield High School. The Kilties, founded by Dr. R. Ritchie Robertson in 1926 as a constructive activity for high school girls, are most famous for their performances of the Highland fling and the sword dance at homecoming. School superstition said that if Dorothy did not touch the swords during the dance, then the football team would win. This group has since inspired other high schools to institute female Scottish drum corps. In the photograph, Dorothy wears a sterling-silver broach with a large yellow gem given to her by Dr. Robertson when she became the drum major. Dorothy, the daughter of Ben Moskowitz, a Jew, and Lottie Moskowitz, an Episcopalian, is the only one of her siblings to remain Jewish as an adult. (Courtesy of the History Museum for Springfield–Greene County.)

DISCOVER THOUSANDS OF LOCAL HISTORY BOOKS FEATURING MILLIONS OF VINTAGE IMAGES

Arcadia Publishing, the leading local history publisher in the United States, is committed to making history accessible and meaningful through publishing books that celebrate and preserve the heritage of America's people and places.

Find more books like this at
www.arcadiapublishing.com

Search for your hometown history, your old stomping grounds, and even your favorite sports team.